P9-CAF-093

Terry Barrett

Talking about Student Art

Davis Publications, Inc., Worcester, Massachusetts

ART EDUCATION IN PRACTICE SERIES

Marilyn G. Stewart

Editor

Terry Barrett

Talking about Student Art

Series Preface

Follow an art teacher around for a day—and then stand amazed. At any given moment, the art teacher has a ready knowledge of materials available for making and responding to art; lesson plans with objectives for student learning; resources for extending art learning to other subjects; and the capabilities, interests, and needs of the students in the artroom. Often working with a schedule that requires shifting several times a day from working with students in preschool to those in elementary, middle, and high school, the art teacher decides what to teach, how to teach it, whether students have learned it, and what to do next. The need for rapid decision making in the artroom is relentless.

The demands continue after school as the art teacher engages in assessment of student learning, curriculum planning, organization of materials, and a wide range of activities within the school community. Although most teachers want to be aware of and to integrate into their teaching new findings and developments within their field, they are pressed to find the time for routine, extensive reading of the literature.

Art Education in Practice provides the art teacher, museum educator, student, scholar, and layperson involved in art education with an overview of significant topics in art education theory and practice. The series is designed to meet the needs of art educators who want to know the issues within, the rationales provided for, and the practical implications of accepting curricular proposals presented from a variety of scholarly and political perspectives.

The emphasis of the series is on informed practice. Each text focuses on a topic that has received considerable attention in art education literature and advocacy statements, but one that has not always been accompanied by clear, concise, and accessible recommendations for the classroom. As new issues arise, books will be added to the series. The goal of the series is to complement the professional libraries of practitioners in the field of art education and, in turn, enhance the art-related lives of their students.

Editor's Introduction

Children often take pride in the things they make and, from an early age, present these objects to others and await their comments. All too often, teachers, parents, and peers respond with simple and ultimately unhelpful comments such as "That's nice" or "Well done." At times the response takes the form of a question: "What is it?" or "What have you made here?" Usually, the conversation ends when the child then merely points to the artwork and identifies what is presented. Rarely is the child provided the opportunity to hear others discuss meanings conveyed through artworks. Discussions with peers can be rich, layered, and revealing.

Artrooms are busy places. In many art programs, especially where scheduling is tight, students leave with their artworks and never again consider them in the context of an art class. In most art classes, only limited time is devoted to thoughtful consideration of meanings expressed in their own artworks and those of their peers. The reasons for this are related, in part, to the way in which art teachers and parents themselves have been prepared to respond to artworks they encounter.

Thoughtful reflection about experiences can provide new insights and questions—the stuff of which artworks are made. Through a cycle of art making and reflecting about meaning, students no longer view art making as simple manipulation of materials; instead, they see the process as an experience through which they comment on and ask questions about what matters to them. When reflection is collaborative, students benefit from the insights and questions raised by their teachers and peers. If students see that others have not interpreted their artwork in ways they had hoped, they can work toward better artistic expression of their ideas. By attending to the meanings interpreted by their peers, students can build upon the ideas conveyed as they engage in subsequent art-making. They also can bring new insights to their future encounters with artworks made by others.

This book is about ways to enhance thoughtful reflection about student artworks. Teachers interested in improving their skills in facilitating dialogues about art will find realistic models and many suggestions to assist them. Terry Barrett, long known for his work in art criticism, including two previous books on the topic, focuses on interpretation of meaning. In this book, he brings knowledge from a decade of engaging children and adults—in a variety of school and community settings—in thoughtful talk about art. He brings excerpts from many of these dialogues, along with honest, straightforward reflections about them from his perspective as dialogue facilitator. Teachers will identify with Barrett's role in these dialogues, and recognize their own students among the participants. With the author, they will see when and why dialogues go just right, and will look for solutions when things go awry. They will see that students can and do talk about their work with a great deal of sophistication, and they will learn how to make this happen in their own classes.

Grounded in a sound theoretical perspective many years in the making, this book presents the real world of students, teachers, art-making, and responding to art. When students reflect upon what matters to them, their self-esteem is enhanced. When students see their peers expressing important concerns through their artworks, they develop a sense of empathy. When ideas and values are shared, a sense of community is fostered. For these reasons, the practices suggested by Barrett have significant implications that reach beyond the day-to-day confines of the artroom.

Marilyn G. Stewart

Publisher: Wyatt Wade
Editorial Director: Helen Ronan
Production Editor: Nancy Wood Bedau
Manufacturing Coordinator: Steven Vogelsang
Assistant Production Editor: Carol Harley
Editorial Assistance: Robin Banas
Copyeditor: Lynn Simon
Design: Jeannet Leendertse

Library of Congress Catalog Card Number: 97-069073
ISBN 10: 0-87192-361-0
ISBN 13: 978-0-87192-361-5
10 9 8 7 6 5 4
Printed in the United States of America

For Pamela Reese

Table of Contents

Chapter *5*

General Recommendations for Interactive Group Critiques93

Acknowledgments to students, teachers, and colleagues

I extend deeply felt gratitude to the hundreds of students who participated in discussions that form the basis of this book, and to their teachers: Judy Butzine, coordinator, and Howard Bernstein, artist, ("ArtWeb," Boys & Girls Clubs of Metropolitan Phoenix, Phoenix, Arizona); Linda Chapman and Toby Rampelt (Huber Ridge Elementary School, Westerville, Ohio) Terese D'Amico (Thomas Jefferson Elementary School, Euclid City Schools, Euclid, Ohio); Sharon Daugherty (Thomas Elementary School, Dublin, Ohio); Jann Gallagher (Euclid City Schools, Euclid, Ohio); Lori Groendyke (Harrison Elementary School, Sunbury, Ohio); Rebecca Hartley, student teacher (Ohio State University, Columbus, Ohio); Roxanna May-Thayer and Sebastiao Pereira (South Mountain High School, Phoenix, Arizona); Pamela Reese (Westerville Public Schools, Westerville, Ohio); Kitty Rose and Linda Duvall (Roosevelt Elementary School, Euclid City Schools, Euclid, Ohio); Peggy Sivert (Costa Mesa High School, Manhattan Beach, California); and Margo Tassi (Philadelphia Public Schools).

I am also forever grateful for the encouraging critical comments of friends and colleagues who read the manuscript. Jann Gallagher (Euclid City Schools, Euclid, Ohio) and Sydney Walker (Department of Art Education, Ohio State University) diligently and faithfully read and thoroughly commented upon every chapter as it was written. Miki Baumgarten (UCLA) read the finished draft and provided valuable and encouraging comments, and Lynn Galbraith (Department of Art Education, University of Arizona) was particularly diligent in reading the manuscript and its revisions, offering valuable insights and encouragement. The collegiality of these readers made this project much more enjoyable than it would have been without their care and concern, and their critical insights improved the original manuscript.

Thanks to Marilyn Stewart, series editor, for suggesting the topic of this book and for providing me the opportunity to explore new territory. Thanks also to the teachers who reviewed the manuscript, including Craig S. Kaufman (Curtin Middle School, Williamsport, Pennsylvania); MaryAnn Horton (Camel's Hump Middle School, Richmond, Vermont); and Jeff Dietrich (Oley Valley Elementary School, Oley, Pennsylvania).

I am grateful to the J. Paul Getty Trust and Leilani Lattin Duke, Director of the Getty Education Institute for the Arts, Los Angeles, California, for generously providing me time to write much of this book while I served the institute as a visiting scholar.

Finally, my thanks to Davis Publications, without whom this book would not have been brought to fruition.

Terry Barrett

Introduction

We usually think of studio critiques as discussions between professors and college art students to improve student art-making. This book, however, is not for college professors, but for teachers—especially art teachers and classroom teachers who teach art— who struggle with getting students to talk thoughtfully about the art that they and others make. It shows what students, from kindergarten through high school, can do when challenged to think and talk about art, and it offers teaching suggestions. The book's goal is to broaden studio critiques to help students become willing, intelligent perceivers of and thinkers about art, in all its manifestations. Discussing their own art teaches students to think critically about art and its relationship to the world.

The emphasis of this book is to improve students' thinking and talking about all art, most especially the art of their peers. This seems a good place to start to teach children to think critically about art and its relationship to the world. The art of their classmates will be intellectually accessible to students, and probably more so than the work of professional artists. If children and older students learn to perceive and inquire and discuss the art of their classmates, they will likely be able to make the transfer to talking about the art made by adults that is exhibited in museums and other community settings.

Art-making is often a solitary experience. After students have made their artworks and participate in a group discussion about what they and their classmates have made individually, they can reflect, return to individual work, implement what they have learned from others, and often improve their art-making. Because they see that their teachers and classmates take their artwork seriously, they will probably devote more energy and commitment to it.

The book begins with a look at a typical college-level critique, but then parts ways with traditional critiques and offers new approaches to critical discussions for younger learners. A sampler of critiques offers a range of ideas and activities to try in your own teaching, and also presents realistic expectations of what you might do with students of different ages and circumstances, and their art. The book continues with investigations of interpretive critical discussions and evaluative discussions, and a critique with adults. Finally, practical suggestions for leading critiques are presented. An appendix offers worksheets to duplicate for students.

My primary goal in writing this book is not to improve students' abilities to make good art, although that may be a desirable secondary outcome. By engaging in serious and thoughtful discussions about their artworks, students will likely improve their art-making. Because they will see that their teachers and their classmates take their artworks seriously, they will likely devote more energy and commitment to their art-making. The most important goal of the book, however, is to increase students' art learning in a broad sense so that they ultimately want to have art as a part of their lives now and forever. I want students, young and old, to develop propensities for and skills of looking thoughtfully and lovingly and enjoyably at art. Good critical discussions will show learners that art provides unique insights into the world in a pleasurable and engaging way.

The discussions within each chapter generally begin with younger students and move to those with older students. Although you do not have to use the book in sequential order, be aware that, for instance, high-school students who have not talked about art

are, in some respects, at the developmental level of kindergartners who must learn basic principles of art. Maturity of age does not necessarily produce maturity in thinking about art.

I've tried all of the activities and suggestions with students in classroom situations. These suggestions come from my work in schools over the past ten years as an art critic-in-education sponsored by the Ohio Arts Council. In this and related capacities, I have been invited to many schools in Ohio and around the country to engage students in thought and talk and writing about art. The critiques presented in the book—all made from audiotape recordings—are excerpts from longer discussions. Within the text of the critiques, italics indicate my voice. Although the excerpts do not contain the speakers' pauses or interruptions, I have tried to be faithful to the tenor of the conversation and what the students said. Within the transcriptions are bracketed descriptions and comments so that you can reflect on my decisions and think about what you might have done better or differently.

Student names are fictional, but footnotes provide the teachers' names and demographic information about their schools. I purposely sought a diversity of populations—students at risk of dropping out; inner-city students in eastern, western, and rural schools; students of different races, cultures, and classes; students in artrooms and in general classrooms; and students from kindergarten to adults in the workplace. All of the teachers and some of the students referred to in the book have read and approved what has been written about them.

I offer this book as encouragement for teachers to try the activities presented, to invent their own, and to share them.

Chapter

1

Studio Critiques: As They Are and as They Could Be

I recently walked into a class of third graders and told them I was an art critic and that I was going to have them be art critics that day. I asked them what they thought they would do as art critics. A boy raised his hand and said, "We're going to make fun of artists?"

A Studio Critique Vignette

The studio critique is likely as old as art-making itself, if "studio critique" means the common activity of artists talking about their work with other artists. Today, studio critiques are conducted mostly in college art courses. A few years ago, an editor of an art magazine described an intensive two-week drawing workshop she took. The participants in the workshop, which included many critiques, made drawings all day and then participated in critiques in the evening.[1]

Two hours into the first session, the class began a critique. The editor-student wrote that "we pin our drawings to the walls of an adjacent studio, and [the professor] lectures us." The professor said the class was "about perception, not about style," and stressed the importance of reorganizing the shape and size of the paper, considering positive and negative space, and respecting "the integrity of the rectangle." He said, "Drawing is not occupational therapy."

Later that day, the professor criticized the editor for "making a shopping list—you're not observing the connections between things." The next day, he focused on the importance of "correcting" the editor's drawings, saying that correction is the "lifeblood of the drawing." Then the professor "scolded" her for coloring her drawing, told her that she was coloring because she didn't know what else to do, and said that instead of coloring, she should be looking for "the relationships between the different forms." On day five, the professor took the brush from the editor's hand and on her paper boldly redefined the figure with which she had been struggling.

At the start of the second week, the editor wrote that "some of the lessons are starting to sink in: correct obsessively; look for relationships; don't draw clichés." The professor told the students, "We're on a quest for the power of the image. So far, these still look like drawings . . . pay special attention to the lower right because that's the most important corner, the one artists often ignore."

On day nine, the professor said he was disappointed in the progress of the class. On the final day, he was "provocatively silent, regarding the works thoughtfully. He chooses several for a show of student work." At one point in the workshop, the editor thought, "Why would anyone want to be an artist?"

Anyone who has taken college-level studio art courses probably remembers similar experiences, trying to understand what the professor was after, and to make an artwork that could both provide personal satisfaction and please the professor.

What the Studio Critique Should Not Be

Many aspects of the critiques described above are typical of college level critiques for art majors. They are generally not, however, suitable for younger learners.

- Critiques are usually judgmental: "You're not observing the connections between things."
- Critiques are often negative: The professor was disappointed in the progress of the class.
- Critiques are prescriptive: "Pay special attention to the lower right because that's the most important corner."
- The professor's explanations of what he or she wants are sometimes oblique: Respect "the integrity of the rectangle."
- Approval is given reluctantly, if at all. When it is given, it is sometimes silent and nonverbal: The professor was "provocatively silent, regarding the works thoughtfully. He chooses several for a show of student work."

- Above all, the primary purpose of the critique is to help students improve their art-making abilities from the point of view of the professor: The professor took the brush from the student's hand and redefined the drawing she was working on.
- Critiques are directed and dominated by the professor; the students are listeners: "We pin our drawings to the walls of an adjacent studio, and the professor lectures us."
- Critiques are often occasions for a professor to put forth his or her view of art as the desirable view, and sometimes by implication, the right and only view: The class is "about perception, not about style" . . . "Drawing is not occupational therapy."

Many art students have had negative experiences in college studio critiques.

The worst critique I had was like chickens pecking at the wounded chick. It was a 400-level graphics class. We pinned our works on the wall and discussed all of them. The class was so competitive that students tried to criticize each piece, to name something bad in each one. A very unpleasant technique.

My worst critique was in a lithography class where the professor could not talk about anything other than representational work, so he ignored my work and some others.

The worst critique involved the instructor's purely negative comments about my work. He seemed to attack me. His emphasis was on poor composition and "tricky" technique. I had no opportunity to explain anything. I benefited in no way.

My worst critique happened when we were to critique our own work and the work of our peers. Nothing constructive came out of the critique. Nobody really knew how to critique or discuss the art. It was a lot of short answers like "I like it because I like it."

And What the Studio Critique Could Be

Although this book is not about college-level critiques, most people who have degrees in art and art education—and therefore had studio courses and workshops—have likely been influenced by those critiques. It is these educators who must consider what they want to take from those experiences and bring into their classrooms today. Following are the comments from some art education graduates about their best critiques.

My best critique was with a visiting artist. She asked questions . . . about what we saw in a work. She asked for description and interpretation with little attention paid to judgment. She guided students in their responses by probing and inquiring, and then gave her responses that were more evaluative in nature but with the purpose of illuminating strengths and weaknesses. The process built trust so that participation was great.

An artist who judges shows picked out works and told why it was good or where it could be improved. Gave sound, fair reasons for either good or bad. Learned many ideas of how to look at art and how to improve it.

One professor knew when students' answers were getting repetitious, and he led us into the work with the right types of questions. Questions that made us look deep into a work.

What these students thought were good critiques were those that were guided by a leader with a sense of purpose; those in which the students could speak and participate; and those that included more

than judgment—and when judgments were offered, they were positive as well as negative, and were accompanied by reasons and sometimes by explicit criteria. The students went away feeling good about their experiences in these critiques, and believed they had learned something about art.

Modifications to the Studio Critique

Because of the current emphasis on teaching art criticism, as well as other content areas beyond making art, art educators need to consider art criticism in the context of making art. Critiques have a place in art teaching; most professors and many art teachers of middle- and high-school students consider critiques essential to their teaching. The purpose of this book is to improve critiques in elementary, middle, and senior-high schools where they are already being practiced, and to introduce critiques to those teachers who are not yet using critiques. This book examines studio critiques with the intent to modify them in three ways.

Viewers as Central to the Critique

The first modification is to put the primary responsibility for talking during the critique on the viewers of the artworks, not on the teacher or the artist. For students to be articulate about art, they need to practice talking about it. Listening to the teacher may provide some behaviors to copy, but students also need direct experience. The teacher's role becomes that of facilitator of thoughtful discussions of students' art, preventing random, unconnected, and ill-conceived comments. The viewers' role is to participate in a fruitful critical dialogue helped along by the teacher's carefully formulated questions and redirection of answers. The viewers become responsible for thoughtful, respectful interpretation. In the art world after and outside the art class, no artist will likely be standing next to an artwork, explaining what it means.

More Interpretation, Less Evaluation

Another modification to critiques is to spend more time interpreting art and less time evaluating it. Interpretation is the critical activity of deciphering what a work might be about. To evaluate or judge a work of art is to determine how good it is or how it is good. Critiques should not ignore judgments of art but should place more emphasis on interpretation. If viewers are open-minded and examine an artwork seriously, but their examination leads to unclear, contradictory, or unreasonable interpretations, perhaps the art is lacking coherent expression by the artist. If, however, the artwork generates keen viewing, many compatible, if different, interpretations, and interesting discussions, then it is likely a powerful work of art. Once a work has been thoroughly considered interpretively, judgments are likely to follow readily and easily. (See Chapter 4 for examples of evaluative critiques.)

An interpretation of an artwork necessarily includes descriptions of it. Interpretations are a synthesis of descriptive facts and observations, and also include syntheses of how form and media affect subject matter—what some call analysis. For the elementary, middle, and high school, considering form in relation to interpretation, or form in relation to meaning, is sufficient. Always beginning a critique with descriptive observations may quickly become boring. Often, a better approach is to start with an interpretive question and then ask for descriptions to support the answers.

Leaders of critiques sometimes do not ask for interpretation because they assume that everyone knows what the art is about. This is especially true when the art has been made for a given assignment

and is known to everyone participating in the critique. But the art that students make might be different from what the teacher intended them to make. In a dynamic class, students might provide different realizations of an assignment, going beyond the intent of the assignment and expressing more than what was stipulated. If the viewers fully understand the artwork, an explicit judgment might not be necessary—it might be obvious that the work is good just because it is able to sustain the viewers' interest.

The Critique as Art Criticism

The final modification is to bring studio critiques closer to the art criticism practiced by professional critics. Criticism is informed discourse about art for the purpose of increasing understanding and appreciation of art. The studio critique is a hybrid form of criticism, usually conducted primarily for the artists whose works are being discussed. In this sense, critiques are different from professional criticism. Professional critics write about art, and they write for their audiences, sometimes millions of people. They write to inform their readers about artists, exhibitions, and artworks. Although the artist may read what the critics write, the critics do not write for the artist. Critiques are for artists; criticism is for an audience much more inclusive than the artist. Many of the suggestions in this book are drawn from practices of art critics rather than practices of college art professors.

Criticism is dependent on art-making, and it sometimes influences art-making. Similarly, studio critiques with students can affect their art-making. If critiques are interpretive, students will learn that their artworks can convey meaning. If critiques are not overly negative, students will be encouraged to continue making art that is meaningful to them and their viewers. They will likely strive to be more expressive in media, rather than focusing only on improving their techniques. They will also strive to express meaning in their artworks and to find meaning in the art of their classmates and other artists.

If students are to learn about art in all its multicultural variations—learning through art history, aesthetics, and criticism—good educational sense says that critiques need to be more like the criticism that students will read the rest of their lives. If they are to become citizens who enjoy looking at, reading, and talking about art, they cannot experience criticism as negatively judgmental and prescriptive. If so, they might finish school believing that art is primarily about technique and skill rather than meaning, and they might forever wrongly believe that art criticism is making fun of artists.

Notes

1 Ann Landi, "So You Want to Learn How to Draw?" *ArtNews*, October 1995, 140–143.

Chapter

2

A Sampler of Critical Discussions

This chapter contains a sampler of critiques with groups of students of various grade levels. The discussions center around artworks of different subjects in different media in various regions of the country. The sampler illustrates the principles presented in Chapter 1, and begins with elementary-school students and ends with high-school students. Teachers of young students can benefit from reading the high-school discussions; similarly, high-school teachers can learn from the discussions with elementary- and middle-school students. Reading what older students accomplish in critiques offers a sense of what can be accomplished in teaching art. Reading elementary- and middle-school critiques can show what young students are already capable of thinking and saying about art; these younger learners may inspire high-school teachers to challenge their own students—if they have not had experience with critiques— to talk about art in organized groups.

Try This

Whether it is good to repeat or not is arguable, for any age group. Some educators say that repeating encourages speakers not to speak up, and listeners not to listen to the speaker; instead, the students wait for the leader to rephrase or repeat. Other educators say that repetition is a good reinforcement.

Older learners and learners who are more confident probably do not need repetition. If comments are inaudible, try reiterating so that everyone can hear them. Check to see if everyone is listening by asking a question: Did you all hear what Kyle said?

2.1 Benjamin Sobiech, grade 1, Shakey the Clown, *1995. Tempera on paper, H: 20" (50.8 cm).*

A Beginning

This first discussion moves from questions meant to elicit descriptive information to those that require interpretive thinking (what the artworks are about and what they express). The critique does not address judgments. The critique closes with a discussion of what the students learned.

Grade Level: 1, 27 students[1]

Artworks: tempera paintings of clowns

Duration: excerpts from a 35-minute critique

This is a suburban school district; most students are from middle- to upper-middle-income families. The clown paintings were based on an earlier project in which the students made realistic self-portraits. For the clown project, the art teacher, Ms. Reese, wanted the students to be more imaginative and less realistic in their art-making. Ms. Reese asked them to think of themselves as clowns they would like to be, and then to express their personality through the persona of the clowns. The class discussed professional clowns, their study of clowning, and the design and copyright of original clown faces. The teacher discussed visual exaggeration of facial features and showed examples of abstracted faces by Picasso, Matisse, and van Gogh.

Students sat on the floor of the school lunch room, which also contains a stage and serves as the artroom. The students were attentive but shy, and did not speak very loudly. Ms. Reese was quietly present in the back of the class observing and did not orally participate until the end during a summary discussion of what we had done.

Leader *Let's start with this clown.* [My choice of the particular picture was arbitrary; any of the pictures would have sufficed to start the conversation.]

What can you tell me about this picture? [An open-ended, nonthreatening question can elicit any response—descriptive, interpretive, evaluative, and so on—with which to begin a discussion.]

Shelly It's a funny clown.

It is a funny clown. Let's start with that. Do you all agree that this is a funny clown? [Because of Shelly's topic, I moved the questioning from the general to the specific, with interpretive questions about if and how the clown is funny.]

Group Yeah.

What makes this clown funny? Who has an idea? Kyle?

Kyle Colors.

What's funny about the colors?

Kyle There's all kinds of colors.

A lot of colors. [Repeating of responses, often with oral emphases, can reinforce what students say, and ensure that they all heard what was said.]

Would all colors be funny, or just some colors? [I wanted to get the students thinking that colors in isolation are not funny: how colors are used is what makes them funny.]

Group Some.

What makes these colors funny?

Mary Bright.

Anything else you can tell me about this clown? [The students couldn't further the color discussion.]

Nicholas? [Nicholas, a boy who was inaudible a moment earlier, was making eye contact but not raising his hand.]

Nicholas The ears. [Now he was speaking so that we could hear him, and it was a good decision not to coerce him to speak more loudly earlier.]

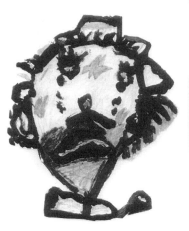

2.2 Chad Kisor, grade 1, Saddy the Clown, 1995. Tempera on paper, H: 20" (50.8 cm).

Calling students by name, listening to what they say and repeating it, smiling, and maintaining eye contact encourages them to be forthcoming with answers. This is true for any age group.

In the midst of a discussion about representational artworks, viewers of all ages tend to forget that a picture is an expression made by the artist. The picture is more than a real thing in the world; it is a person's interpretation of something or someone.

What about the ears?

Nicholas They're small.

They are small ears. Charlie?

Charlie He has a black nose.

Matt He's wearing a hat.

Kyle He has green ears.

[The students' answers came quickly. Moving on from the specific color and humor questions had been a productive choice.]

Let's go to another one. [This seemed a long enough time on this image and moving to another artwork maintained the students' interest.] *What do you notice about this one? Terry?*

Terry It's sad.

It's a sad clown. What makes this one sad? [This is an interpretive question based on what the students took to be a factual, descriptive statement. To say that anything or anyone is sad requires interpretation on the part of the speaker. The students then offered reasons for sadness, including "tears" and "a frown."]

Sally He has a mustache.

Does that make him sad? [This question was asked to indicate that a mustache in itself would not necessarily make someone look sad.]

Group No.

What else makes this one sad? Robby?

Robby Well, he has tears.

Yes, we have noticed that. [This response encourages the first graders to listen and to try to remember, and discourages exact repetition of a point already made.] *So, now we have the happy one and the sad one.* [This statement summarizes the discussion so far, and points out some conclusions that have been made. The critique proceeded in similar fashion, with

another picture. The students offered similar observations—big eyes, a big head, purple hair, a flower on his shirt. The students also provided reasons why the clown was happy.]

What did the artist do to show you this was a happy clown? [This question implies that the child artist did something to make the viewers believe that the clown was happy. The artist had made choices, and the viewers were responding to them. The critique continued with similar questions about different pictures. The students talked about happy clowns and sad clowns. Frequently asking how the artists made the clowns look happy or sad provided reasons for the first-graders' assertions. Because one student mentioned detail and others provided evidence of detail in the works, I changed the topic. The class looked for pictures with the most detail and the least detail, and then compared them.]

Do you think this girl clown might have a brother clown in these other pictures? [The answers to this would determine if the students could draw family-type relations among the clowns. Answers came quickly, and interest in the discussion was renewed by the change of direction. The students looked for clowns that might be related—brother clowns and sister clowns—and gave reasons why they looked related. The students formed a grouping of clowns that looked as if they could be from the same family. At that point, some of the students were restless.]

I have a new question. Think about this before you answer. If you had a chance to spend an afternoon with one of these clowns, which clown would it be? And why? [This new and different question brought the students' attention back to the discussion.] *Who haven't we heard from in a while? Kelly, which one would you like to spend time with?*

Kelly Useful. [The students had given names to their clowns, and the art teacher had labeled each picture.]

Useful the Clown. Okay, why would you like to spend time with Useful?

Kelly Because it's pretty.

Does anyone else want to spend time with this one? Okay, Erica. You want to spend time with this one? Why? Tell us.

Erica 'Cause I'd like to get her to smile. [The sensitive answer indicated that Erica could put herself into the shoes of an imaginary other.]

Oh, you'd like to see if you could get her to smile. That's a good answer. How would you try to get her to smile?

Erica I'd let her decide what she'd like to play with, what we're going to play next.

You want her to decide what you're going to play next. [At this point in the critique, the class time was almost up. Closure was needed.] *Did you learn anything today about the clowns?*

Group Yeah.

What did you learn? Tell me some things you learned about what we did today. What did you learn today about your pictures? [Questions like these can provide assessment information: Did they learn anything? Might they remember what was done? What changes might I make in the future? The students said that they learned that clowns can be grouped in families, that some are happy and some are sad, and that some have hats and some don't.] *I'm surprised that you were able to talk for a whole half an hour about these clowns. Were you surprised by that? Who is surprised and why? Who isn't surprised and why? I want reasons.* [Pause.] *Andy? Why were you surprised?*

Andy Stayed awake. [Andy was not trying to be funny, and this is a good criterion for first graders.]

Nicholas?

Nicholas I can learn a lot more about the clowns.

Good. Are you happy with your clowns? Give us some reasons why. Any reasons why you're happy with them?

Matt They're very colorful.

Samantha If you look at the clown long enough, you could probably get one detail off of each of these clowns and make another clown. [Samantha took a long time to get this thought out, but she had a good idea about synthesizing different aspects of clowns into one new clown. During the critique, she had learned how she might make a new and different clown. She had applied the discussion to her own future art-making—a desirable outcome of any critique.]

Kristi Can you tell us what you learned today? [By asking a thoughtful question, Kristi brought me into the discussion.]

Sure! I learned that first graders can talk for a whole half hour about the artwork that they made, and that was new to me. I didn't know that before. I learned that you could point out a lot of things in the clown pictures. I learned that you had some good vocabulary, like the word "detail." I learned that you could make families out of the clowns. [Before the end of the class, the art teacher offered her observations about what the students had done.]

Ms. Reese I'm amazed that this class could talk this long. I didn't think that you could, and I'm really surprised. You did good today, just by sitting here and being polite. That's really a good accomplishment. And you have smart things to say. Remember when we talked about exaggerating parts in the very beginning of this project? These clowns have really different personalities, just like you do. [Here

she was reinforcing what she had wanted them to learn when she introduced the lesson. Ms. Reese finished talking, and the discussion moved to what the students had done as critics.]

I want to tell you something about what art critics do, because I'm an art critic. Art critics look very carefully at art, just like you did, and then they tell people what they see. I write articles and books, and sometimes I talk about art. That's what critics do. They look very carefully and then they tell people what they see, because what you see, I don't see, and I might not see it unless you tell me about it. Some of those things I didn't even notice until you said so. So that's what critics try to do. Yes, Andy?

Andy I'd want to spend time with Slappy the Clown.

Why?

Andy 'Cause he would slap you! [The class laughed. This was not the best way for the discussion to end, but it was a clear signal that it was time to stop.]

Thanks for your attention. You were good critics.

Reflection

The young students participating in this critique are just beginning to talk about art. I had to attend to what they were saying, and what they could and could not express. I had to remind myself to be patient, that this was a building process. If these students continue looking, thinking, and talking about art, by the fourth grade, they will be much more adept and insightful. When they are teenagers, they will radically change how art is talked about in high school.

The questions I asked during the discussion emerged spontaneously, based on responses from the students. I knew generally where I wanted this discussion to go, but made many key decisions along the way, sometimes went astray, and then brought the group back to sharper focus on a topic. Having a direction, but spontaneously following leads from students, is typical of critiques with learners in the middle grades as well as in high school.

Good critiques require good questions, one at a time, careful listening to the responses the questions elicit, formulation of a responsive and timely next question, careful listening, and a new response or question, throughout the length of the critique—whether that be five minutes or fifty.

These questions are basic to a critique with any age group: What do you see? What does it express? When I receive descriptive, factual information from a question, I try to move students immediately to consideration of interpretive implications of their descriptions. Some critique methods advocate first describing thoroughly before interpreting. I think it more beneficial and natural to build on description all the time. Descriptions should lead to interpretations, and interpretative questions should be backed by some descriptive evidence. Description and interpretation are linked and necessarily circular.

I kept my attention on asking questions and eliciting answers—not on giving my answers. I probed for more information, trying not to settle for nonanswers, incomplete answers, or single answers. I introduced the idea that the students needed reasons to support their assertions.

Knowing when to redirect a discussion through new questions and when to end a discussion is difficult and sometimes intuitive. Redirecting the discussion after receiving repetitious answers is often effective in moving the critique along. However, if a new series of questions does not elicit new energy, I stop.

Emotion in Artworks

This critique is about dealing with difficult emotional topics that emerged in art made within an urban school setting, drawings based on Picasso's *Weeping Woman,* 1937.

Grade Level: 1, 31 students[2]

Artworks: colored-pencil drawings

Duration: 20 minutes

Students attend an urban elementary school in southern California. The first-grade teacher explained why she had chosen this particularly sad image of Picasso's. In her effort to build art into her daily curriculum, she had been using Picasso and Cubism to explore shapes with the students. She also explained that sadness is a part of the students' daily lives, that many of them are familiar with gang-related violence, and that the teachers in the school frequently help the children deal with sadness.

This is an example of a critique for which I predetermined the questions based on the artworks and the situations. I asked: "Why is the woman in Picasso's *Weeping Woman* crying?" "How did Picasso make her look sad?" "Have you ever seen women crying?" "What were they crying about?" "What have you been sad about?" "How did you make your pictures of crying women look sad?" "How are your pictures like Picasso's?" "How are they different?" "When you are sad, do you make art?" "Does it help?"

Leader *Why is the woman in Picasso's* Weeping Woman *crying?* [The students offered possibilities: she was sad; she was Picasso's wife; she may have been sad "about a big war." Their teacher had shown and talked about Picasso's *Guernica*.]

Try This

Learn about your teaching by making a tape—audio or video—of a critique that you lead. Analyze the recording to learn about your questions and the ways you ask them. Assess how well you facilitate a group discussion about works of art.

2.3 Pablo Picasso, Weeping Woman, *1937. Oil washes and black ink on off-white wove paper, 15 3/4 x 10 1/4" (40 x 26.1 cm). Courtesy of the Fogg Art Museum, Harvard University Art Museums, Francis H. Burr Memorial Fund.*

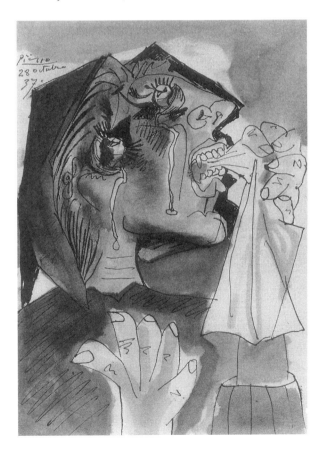

Jorge Maybe they killed her husband.

Raymont She was poor.

Gloria She might need money.

Paulo Maybe she'd like to be rich.

Valentino Maybe she didn't have any food.

[I directed the discussion away from *Guernica*, Picasso, and the war in order to keep the students focused on the topic for this critique: the students' expressions of sadness.]

The children said that they have seen women cry. Each of the children talked matter of factly about these experiences, and did not look sad during the telling. One girl told of her mother crying because her little brother had died when the [umbilical] cord wrapped around him at birth. Another girl said that her mother cried when the girl's father took the girl away without her mother's permission. Another girl said that her father was a gang member and that her mother cried when she had to call 911 when her cousin was shot by a member of a rival gang. One boy's mother was in prison, he thought, because she stole toys for him, but the teacher later privately explained that the boy's mother was a heroin addict and was imprisoned for dealing in narcotics. Another boy told us that his mother cries when his father screams at her when his mother would cook but the food was not right. One girl said her mother cried when she had a baby because it hurt. Then a boy said that his mother cried because she was happy when her baby was born. I acknowledged: "Yes, that's a good point. Your mother probably hurt when she delivered her baby, but she cried because she was happy. We can cry tears of joy. Very good."

How did you make your pictures of crying women look sad? [The students said they made their pictures look sad by showing the woman crying, by using

tears, and by pointing mouths and eyebrows down instead of up.]

How did Picasso make his weeping woman look sad?

Alejandra He put her hands over her mouth.

Roberto She has a handkerchief by her mouth.

Amalia He used shapes.

What kind of shapes?

Amalia Triangles.

Triangles? Yes, he did use a lot of triangles. Do the triangles make her look sad?

Amalia Yes.

What shapes would make her look happier?

Amalia Circles.

[Amalia had made a good observation. In a book of Picasso's paintings that was displayed in front of the class, *Weeping Woman* was facing another, much happier painting of a woman. When the students looked at the two pictures, they noticed that Picasso had used many triangles and angular shapes for *Weeping Woman*, and that the happier woman was more rounded, with some obvious circles that Amalia recognized and pointed out. After the class talked about how their pictures were like Picasso's, the critique moved to how their pictures were different than his.]

How are your drawings different from Picasso's paintings?

Rosillo He used thick paint.

Maria He used different colors [from the ones the students had used].

Tell us more.

Maria On the face.

Yes, I think I know what you mean. Picasso used lots of different colors on the woman's face. But you

2.4 *Anonymous, grade 2,* Weeping Woman (after Picasso), *1995. Crayon on manila paper, 18 x 11 1/2"* (45.7 x 29.2 cm).

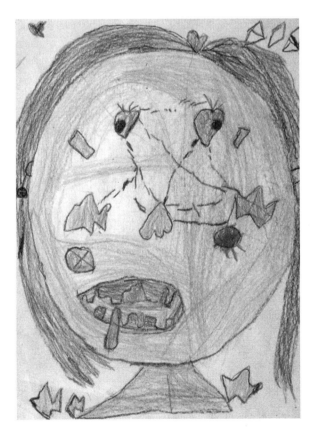

Classroom teachers can collaborate with the art teacher and conduct follow-up critiques about the art their students have made. The art teacher has limited time with students and would likely welcome the classroom teacher's extending the art lesson through talk and writing.

2.5 Anonymous, grade 2, Weeping Woman (after Picasso), 1995. Crayon on manila paper, 18 x 11 1/2" (45.7 x 29.2 cm).

usually used one color on the faces you drew. My face is mostly pink; your face is mostly brown. But Picasso used a lot of different colors for the woman's face. Now I'm going to ask a different kind of question. When you are sad, do you make art? [Some of the students said that they do.]

Ava When I took care of my brothers and sisters they were bored. They drew pictures, and that made them happy.

Rosillo I let my brother scribble with my crayons when he is sad and that makes him feel better.

Cynthia Me and my girlfriend paint pictures and we feel good.

Do you know why making art when you're sad makes you feel better? [The class didn't have any answers.] Do you think Picasso felt better after he painted the crying woman?

Group Yes.

Why do you think so? [They didn't have answers for this question either.] When I'm sad, sometimes I make pictures, and sometimes I write on paper what I am sad about. That helps me not be sad. I'm not sure why it helps, but it does. When I have sadness here [pointing to the heart] and when I write about it on paper, I feel better.

Reflection

Through earlier lessons on Picasso and Cubism, these students had learned some basic geometry, and about Picasso, an important artist. Because of this critique they now knew that they, like Picasso, were able to express feelings in pictures; they could read emotions in both his work and theirs. The class reminded me that one of the values of art is that it can provide a positive release of emotions.

The successful lesson about Picasso that the class-room teacher had taught before the critique is an example of what a classroom teacher with no special art expertise is able to accomplish. Her success provides encouragement to other classroom teachers to venture into more art teaching.

A Critique to Assess Teaching and Learning

This critique shows how a teacher might assess what the students have learned from a studio project. The students reviewed proper use of materials, medium, and technique; they recalled some of what they learned of a particular culture; and they reviewed some principles of design. The discussion gave the students practice in verbally explaining artistic processes, principles, and experiences.

Grade Level: 2, 23 students[3]

Artworks: batiks

Duration: 40 minutes

Students attend school in Dublin, a small upper-income city outside Columbus, Ohio.

Leader *What should we call these?*

Group Batiks.

I've never made a batik. What would I have to do to make one?

Ask students to explain it to you

Allison Make a design with a pencil on paper. If you don't, you won't know what to do.

Pam You'll have to get a cloth.

Okay. What kind of cloth?

Pam Blank.

Would any kind of cloth be okay?

Christine A white cloth. So you could see the pencil marks [when you drew on it].

The discussion of batiks did not show what each individual had learned. A worksheet can often provide a more accurate assessment of an individual's understanding. For example, can the individual students accurately list in proper order all the steps involved in making a batik? This is a question of both logical reasoning and artistic technique.

Try This

To motivate and direct students to review and remember an artistic process, have them explain to someone who was not present during the activity exactly how to do it. What materials are needed? How does the process start? What is done next? Then what? When is the piece finished?

Try This

Have your students plan and produce a videotape of a process or technique, such as batik, that you have taught them. The class could review the steps, and on a chalkboard, list them in order from first to last. A few students could operate the camera. Others could demonstrate each step of the process. The whole class could review the tape, suggest changes, and make improvements. You would then have a tape made by learners for other learners to use. The tape could also be shown to parents, principals, and fellow teachers.

Would velvet work? [The students said that velvet was too dark. They explained that after the drawing is made on the cloth, the pencil design is traced over with paste, and that the cloth is put on a drying rack so that the paste will dry. Then the cloth is dyed.]

Tell me how to dye it. [The students thought that this was a question with an obvious answer and didn't respond, so I rephrased the question.] *If you were teaching me, what would you tell me to do?*

Elizabeth You get a brush, dip it into the jar of dye, and spread it across the cloth. You let it dry, and peel off the paste.

I see that all of you used pastel colors in your batiks. Can you tell me why you did that?

Maria Because they're light colors.

Ben Because if you use light colors and you made a mistake, you could go over it with a dark color.

Oh, I see. That's good. Are there any other warnings that you would have for me if I made a batik?

Christine The dye could stain your clothes. You can't bump the cup of dye and spill it on your batik because it'll make it one color all over.

2.6 L. Alexander Liggett, grade 2, Untitled, 1995.
Batik, 9 x 36" (22.9 x 91.4 cm) .

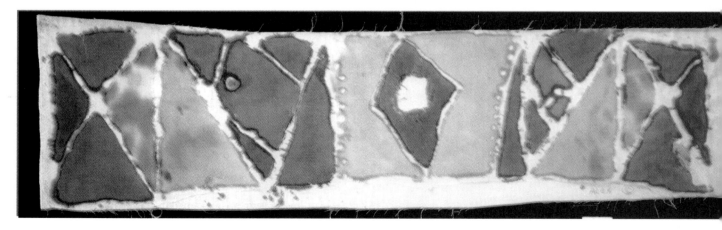

What about the paste? Is it a special paste or will any paste work? [The students answered that the paste was special, but they didn't know what made it special. Although the students understood the principle of the paste resisting the dye—that the paste kept the colors from "running together" by forming "boundaries"—they didn't seem to know the word "resist." They explained that after the paste was removed, there would be white lines on the cloth. I then moved the discussion beyond technique.] *Do you know why these are called Indian batiks?*

Ben We saw some made by people in India. [The class had looked at Indian designs before they began their batiks.]

Maria Sometimes they used berry juices for the colors.

Christine And tea leaves.

[We then moved to symmetrical and asymmetrical balance. The students knew about these and could use the terms accurately.]

Reflection
Through the critique, the class reviewed all the steps involved in making batiks. I learned what they had learned. Likely, no one of the students could have, without a lot of prompting, given me a step-by-step account from beginning to end, without forgetting anything. By working as a group, they helped one another remember what they had learned about making batiks. Having them explain processes of batik made them think and explain in a logical order. They also recalled some cultural details of the subcontinent of India, and they demonstrated knowledge of symmetrical and asymmetrical balance. As well as serving as an assessment for the teacher, the critique provided an opportunity for students to review what they had learned.

A Critique That Didn't Work

Grade Level: 4, 26 students[4]

Artworks: mixed-media drawings

Duration: 45 minutes

These students attend school in a rural, white, working-class community. This critique was not a successful one but is included as a reassurance that not all critiques will be good ones. The students seemed not to have enough of themselves invested in the project to make the pictures meaningful enough to them to provoke an interesting conversation. They were unable to move beyond simple, short, and redundant descriptive observations, and it was difficult to gain any interpretive insight from them about their images.

As motivation for this project, Ms. Groendyke, the art teacher, read aloud a children's book about O'Keeffe, and showed them about twenty reproductions of O'Keeffe's paintings. The art discussed (18 x 24" mixed-media drawings—in tempera, chalk, and oil pastels—based on the art of Georgia O'Keeffe) was on display in the school corridors for an annual spring festival. Next to the display of artworks was an explanatory wall text:

> ### O'Keeffe's Nature by Third Graders
> Students studied the life and work of American artist Georgia O'Keeffe, noting her large, natural subject matter.
>
> Each student selected a small natural object (leaf, pine cone, shell, etc.) to paint onto paper with tempera, filling up the entire space. Students were encouraged to be creative and expressive with their color selections.
>
> Chalk and oil pastel were applied over the dried paintings to create texture and details.

Leader *How are your drawings like O'Keeffe's paintings?* [The students were sitting on the corridor floor in front of the drawings.]

Emily She used nature, and so did we.

Will I used colors like she did.

Mark I filled the page.

[The students' responses to the questions were brief. One student said that a picture had "good color," but when asked why it was a *good* color, she said that it was "blended together." The students did not—and perhaps could not— elaborate. I then tried a different kind of motivation to get them to say more about their pictures.]

Let's try something else. Let's try a new technique. You are an art critic on the radio, and you are going to tell our listening audience about these mixed-media drawings. Remember that the radio audience can't see what you are talking about, so you have to tell them what you see. Also, you want to tell them why you think these are good mixed-media drawings.

Nick They look like they could be in a museum. It's a picture of things that you might find in your backyard. It has sticks and twigs and leaves like in your backyard.

Very good. Who else would like to speak to our listening audience?

Cody I like them because they have different colors and textures and . . .

Cody, remember that our listening audience cannot see these pictures, so you have to tell them what they look like. [Cody needed to be descriptive and to imagine his audience. Critics of any age have to replicate images in words for their audience. The discussion continued, but the students' responses were

not sufficiently descriptive.] *Try to think of things we haven't already told our listening audience.*

Nick I like how the colors are bright, how they stick out, stand out, the textures, how they use nature, and just about everything about them. They're great.

Why are they great?

Nick Because they're beautiful. I like the colors. They are art.

[Although Nick responded well to the initial radio prompt and gave an elaborate first answer, the discussion quickly reverted to simple, unexplained answers. Repeated directions to be specific had no effect.]

Ms. Groendyke It's fine to have an opinion, and I like the pictures too, but I'd like to hear you describe more about them. Remember the time I asked you to pretend that you had a famous work of art, and that it was stolen, and you had to tell the police what it looked like? If you tell the officer, "I had these paintings that were stolen. They were beautiful and pretty," the police aren't going to know what to look for. Try to think of ways to describe these paintings so they can be found. Making judgments without reasons is giving your opinion, not giving a description.

Reflection

This was not one of the better critiques I have led. Even Ms. Groendyke's reminders and suggestions about descriptive activities they had already learned did not help the children further their simple observations and responses. We ended the discussion after about fifteen minutes, rather than continue and perhaps discourage the children as well as the leaders. Perhaps it was the time of the day, my energy level, or the personality of the class. Perhaps the students

Several points can be made about the wall label. First, having an explanation of the project for viewers of the display is an excellent practice. A sign as complete as this reminds the teacher of some of the things he or she had hoped to accomplish in the lesson. Fellow teachers, principals, board members, and parents can read about and see what is being taught and learned in art classes. The student artists are also reminded of what they learned.

Such signage also silently teaches those who read it to look for and read similar signage in galleries and museums. Thus school practice comes into closer alignment with art-world practice, and prepares people to be more aware of information available in museums.

2.7 Kati Zvansky, grade 3, Nature (after Georgia O'Keeffe), 1995. Tempera, chalk, oil pastel, 18 x 24" (45.7 x 61 cm).

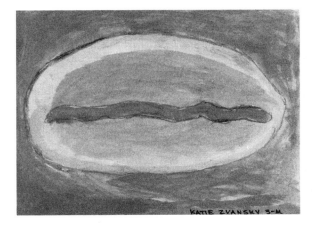

Try This

Using creative strategies, such as the radio technique, can often elicit certain kinds of responses. The speaker must keep in mind that the pretend listening audience cannot see what he or she is talking about; therefore, the speaker must tell exactly what is present and visible in the artwork. The strategy also reminds students that critics communicate to an audience larger than the artist or the teacher.

Set up the radio scenario with two or three radio critics talking to the audience (the rest of the class) about works of art. The audience cannot see the artworks that the critics are talking about. The audience members pretend to call in questions to the hosts, seek clarification, and discuss issues related to the artworks.

Or Try This

Student critics could also interview student artists (or visiting adult artists) on the radio, seeking insights for the pretend listening audience about what decisions the artists made about the artwork, and why.

A similar strategy is to have students pretend that they owned a famous work of art and that it had just been stolen. A small group of students pretend to be art collectors who describe the missing picture clearly enough to a group of "police officers" so that they can locate the artwork. For younger students, the police would have five pictures in their custody. The art collectors identify their missing picture so that the police can select it from the group. Descriptions have to be completely verbal; no gestures allowed.

2.8 Molly Troutman, grade 2, Christmas Angel–Spring Fairy, *1995. Tempera on paper, mixed media, H: 10"* (25.4 cm).

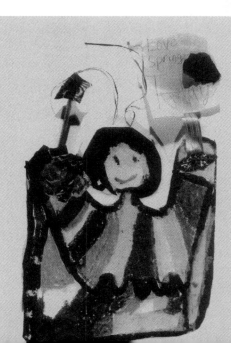

were not invested in the project; maybe there was no "their" there. Maybe they had not identified with the work of an older woman making art in the desert, and making paintings in her style was a mere formalistic exercise that did not inspire them.

Mixing Grade Levels for a Critique

The purpose of this critique is to show some advantages of mixing age groups in a critique. Kindergartners and second graders talked about each group's artwork. The hope was that the kindergartners would look up to the second graders and listen carefully to what they had to say. The second graders might be motivated to talk about art because they had an audience that they would want to please. Further, the younger students might see that the older students could find meaning in their kindergarten artworks; the second graders might realize that their artworks could communicate to a group of viewers other than their peers. Hopes were realized: the kindergartners and the second graders were very attentive during both discussions. The critique, in which kindergartners talk about second graders' work, took place after the second graders had discussed the kindergartners' work. Students at the suburban Columbus school are mostly white, from working-class families.

The second graders' cut-out paper figures were about ten inches high and painted with tempera paint; some had paper shapes pasted to them. The second graders had made Christmas angels the previous December. Now it was spring. Ms. Chapman, the second grade classroom teacher, had told the students some Irish folktales, and now the class was working on transforming their angels into spring fairies.[5]

Grade Level: K and 2, 54 students (2 classes combined)

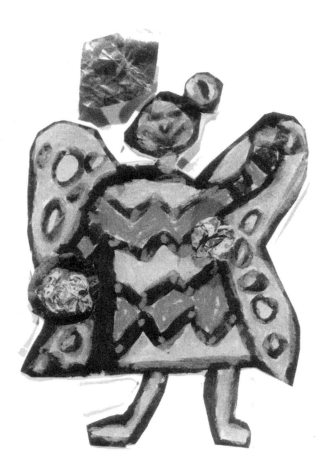

2.9 Erin Jeanine Moore, grade 2, Christmas Angel–Spring Fairy, 1995. Tempera on paper, mixed media, H: 10" (25.4 cm).

Critics need motivation to criticize. Professional critics have audiences for whom they write. A class of students responding to artworks made by another class—and vice versa—will give the critics motivation to be thoughtful about art. The artists will benefit from hearing from critics who have not seen their work before, and who do not know the assignment.

Try This

Writers write for specific audiences. Ask middle- or high-school students to write critically about an artwork of theirs so that a younger brother or sister—or a class of second or third graders—would understand the criticism. Have the writers read their writing to their intended audience to see how well they did.

Try This

Ask middle- or high-school students to make art that would appeal to kindergartners or to people at a senior center. Allow the students opportunities to show their work to their intended audience and to engage the audience in a critique of the work.

Artworks: cut-out paper figures

Duration: excerpt from a 20-minute critique

[The kindergartners had been talking about the figures as if they were angels. Then one kindergartner said that the figure we were talking about was "a butterfly." However, most of the kindergartners thought it was an angel.]

Leader *How can you tell if this is a butterfly or an angel?*

Kate Angels have wings, and butterflies don't have wands. [This was a good answer. As a kindergartner, Kate had made an impressive logical distinction. The second graders knew that the wand was supposed to symbolize a fairy and not an angel. From viewing the figures, the kindergartners and I couldn't figure out with any confidence what the second graders were trying to express with their works in progress. The second graders learned from the kindergartners that they would have to transform their angels further if they were to be seen as spring fairies. Critiques of works in process can inform artists what else they might want to do to their art to realize their intentions for other viewers.]

Reflection

During the critique, the students had genuine insights into the artworks, and the teachers were encouraged to try to engage their future classes in more discussions of art. The mixing of age groups worked. The students were attentive and motivated. The older students enjoyed the younger ones' observations, and the young ones seemed flattered that they were being listened to by the older students. Both groups seemed to have learned what their works communicated and did not communicate—a valuable lesson for all emerging artists.

Critiques as Research

In this discussion, fourth graders talk about first graders' pictures, without the first graders present. Students, mostly from blue collar families, attend school in a rural community. The purpose was to see if fourth graders could be interested in art made by much younger students. The age gap also varied: in the previous critique it was kindergartners and second-graders, and now the critique involved fourth graders in considering first-graders' work. The art was marker and watercolor drawings based on Maurice Sendak's *Where the Wild Things Are*. The fourth-graders did find the artworks and questions to be interesting and a good conversation ensued. By changing variables such as these, you can conduct research about your teaching which will keep your interest and motivation high.

Grade Level: 4, 26 students[6]

Artworks: watercolor and black marker drawings

Duration: excerpts from a 45-minute critique

Leader *I want you to look at these carefully, and pick out one that you think is interesting. Tell us what you think the first-grade artist was trying to show us with the drawing.*

Kyle I think they were trying to show us some wild things.

How many?

Kyle Two.

Is one more wild than the other? [This asks for comparative thought.]

Sheila The brown one looks more wild than the pink one. It looks more scary. The hair is messed up.

Why else does the brown one look more wild?

Becky It looks like the brown one is chasing the pink one.

Try This

Conduct research while you teach. When you teach many classes in the same day, or the same lesson to many classes, change one specific thing in the lesson to see what different results you achieve. Keep track of the results. Decipher which practice resulted in more learning and why. Test your findings. At another time, change another single thing, and then another.

Discuss the results of your experiments with others informally, present the results at a conference presentation, or write about them in an article. Your findings will improve your teaching, and your research will keep you motivated to teach and to learn more about effective teaching.

Try This

Motivate your students toward better art-making.

- Have a class examine and discuss the results of the same assignment from a different class of the same grade level, either from the same school or another school.

- Have younger students talk about the work of older students so that the younger ones can see what they may be capable of making.

- Show older students the work of younger students so that the older students can review what they have already learned.

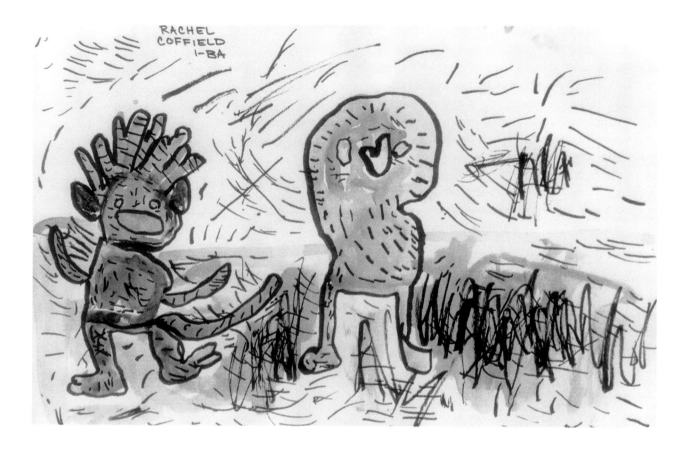

Sam It looks like the brown one is going crazy or something.

How did the artist show that?

Max Because they have it dancing around.

Yes, there's movement in the foot. [A better response would have been to ask again, "How did the artist show that?" Students need to be encouraged to provide reasons for their assertions.]

Sarah The brown one has its mouth open, and the pink one's is closed.

How is the pink one reacting?

Susan It could be the brown one's dinner.

Sally But it's staying calm.

How did the artist show that?

Rory It's just standing there.

Ned Its mouth is not open like it's yelling or screaming.

Reflection

The critique continued through other drawings, with the fourth graders discussing what the first graders had expressed. As a teacher-researcher, I learned that

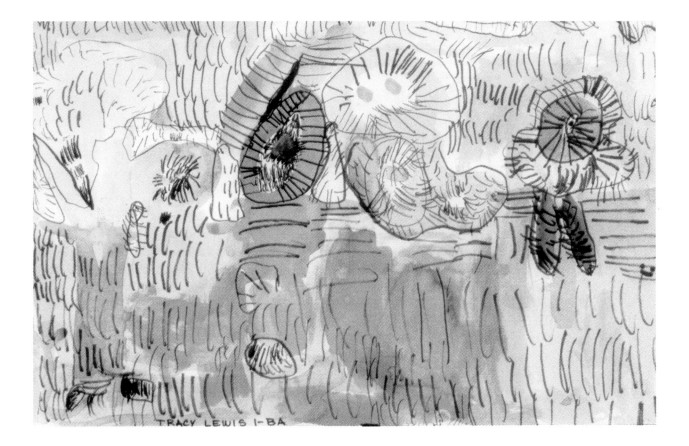

older students could be interested in art made by younger students, and in art made by students other than themselves. I changed a variable in the mixed-age group experiments by removing the audience of artists who had made the art we were examining. The student critics were still motivated to talk about other students' art. As a teacher who wants to learn more about teaching and learning, I tried something different, learned something valuable, and also kept myself motivated as a teacher.

2.10 Rachel Coffield, grade 1, Untitled (*after* Where the Wild Things Are), *1995. Watercolor and black marker, 18 x 13" (45.7 x 33 cm).*

2.11 Tracy R. Lewis, grade 1, Untitled (*after* Where the Wild Things Are), *1995. Watercolor and black marker, 18 x 13" (45.7 x 33 cm).*

Questions that redirect the students' attention are good to ask, especially if the class is not responding. Their lack of response may be simply that they have forgotten the question. Even when the class is responding, and especially when the students are responding quickly, redirected questions ensure that the tudents are considering the original question and not just responding to someone's previous answer.

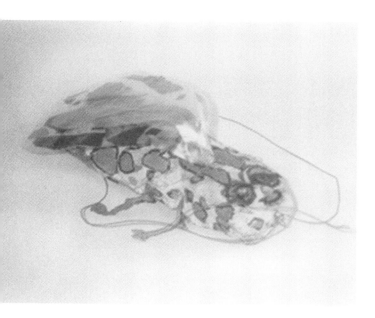

2.12 *A.J. Heckman, grade 4,* Insect, *1995. Papier-mâché, tempera, cellophane, L: 15" (38.1 cm).*

Building Themes in Critiques

This critique builds unifying themes from an open-ended discussion. The critique begins in an open-ended manner. From the students' responses the leader identifies themes that arise and reinforces the students' learning in both science and art.

Grade Level: 4, 27 students[7]

Artworks: sculpted bugs of painted papier-mâché, wire, and cellophane

Duration: excerpts from a 35-minute critique

The art teacher, Ms. Reese, designed an insect sculpture lesson based on what fourth graders were studying in their science class. The school is in a suburban community of predominantly white, working-class families. Ms. Reese challenged the students to invent imaginary insects based on the information that they were learning about real insects. The students used papier-mâché, tempera paint, wire, and cellophane.

Leader *Which sculpture would you like to talk about?*

Erin The purple one. Because it stands out. [The class offered valid reasons as to why and how the artist made the sculpture stand out. The students were on their way with the discussion. The next sculpture was picked because it was "realistic."]

How is it realistic?

Gabriella It has antennas.

Sam The legs are curled like it's walking.

Emma It's low to the ground, and most bugs are low to the ground.

Anton It's a dull color, and bugs usually have dull colors.

Is this the most realistic sculpture of all of them? Think before you say. I'm looking for the most realis-

tic one, and I want reasons. [The students picked a sculpture of a beelike insect with wings, and discussed it for a few minutes. They maintained it was realistic because it had wings and it could fly. However, the wings were disproportionately small for the body. I guided the students to discover what they already knew but hadn't articulated.] *Are there any design changes you might want to make so that it could fly better, or do you think it could fly just the way it is?*

Kate The body looks big and heavy, and the wings might not be able to support it. The face is flat, and it might be better if it was more spherical so it could cut through the wind.

Chris I'd change the shape of the wings, make them wider, so they would have more power.

Rachel Give it thicker legs. Its legs are too thin for the big body.

[We tested Rachel's claim by putting the bee on the floor. The class decided that the legs were not able to support the weight of the sculpted insect. Pursuing this line of questioning about design qualities encouraged the students to think scientifically about how they had engineered their insects, and how they might better design them, especially if they wanted them to be realistic. Their answers were logical, but their reasons would not have come forth if the discussion of realism had stopped with the answer, "It has antennas." Questions that seek more information on any topic are essential for any grade level.]

[In the middle of this part of the discussion, the answers were coming freely and rapidly, so I asked them to recall the question they were trying to answer—how to redesign the bug to make it fly better.]

Yes, you remembered the question. But remember

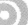 **Try This**

Asking students to divide large groups of their artworks into subgroups is a good activity for elementary-, middle-, and high-school students. Even when all the students have made similar objects, grouping activities can promote careful looking, noticing of subtleties, the making of logical distinctions, and interpretive thought. Ask: How are these objects alike? How are they different? Which seem to belong together and why?

Once students have suggested groupings, question whether the unifying characteristics are significant or trivial. (A trivial grouping might be one in which all the artworks use red. A more significant grouping would be one in which all the artworks rely on exaggerated components of subject matter. Whether a grouping is trivial or significant depends on the students' developmental stage.) Ask: What other groupings could be made? On what basis?

Losing direction when conducting a critique is common. Trying to stick to the topic when many students are offering answers can be daunting. If this happens, tell the class that you need a moment to reconsider what you and they are doing. You might say, "Please put your hands down for a minute. I'd like a moment to think about how to ask this next question. Let me see." At such a point, you could announce to the class that you are about to redirect the focus so that they can better see where the discussion is going.

Try This

Ask: What is factual and what is fictional about these artworks? This question is particularly appropriate for artworks that have realistically depicted subject matter, such as photographic work. The question leads readily into philosophical questions of aesthetics. Ask: Is there truth in fiction? Is there truth in art? These questions are appropriate for students in middle school and high school.

that we are asking if we want to have this insect fly, how might we change its design. We are not saying the insect sculpture is not good just as it is, but we are talking about what we would do to have it fly.

[The students needed to be clear that they were not judging the sculpture as a bad work, but that they were considering the functionality of their objects as designed and engineered prototypes of new insects.

The class then talked about another sculpture, one similar to the insect they had just discussed. They examined how this sculpture was similar to the other, and then how it was dissimilar. This compare-and-contrast strategy works well with most any group of art objects. The students concluded that both sculptures seemed to be flying insects. Based on this response, they were asked to divide all of the sculptures into insects that would fly and insects that looked more suited for the ground.]

I have a new question that I just thought of. What is factual and what is fictional about these insects? Let's start with facts. What is factual about these bugs?

[The students mentioned the sculptures' wings, legs, and antennae. For verification, they cited books they had read, and their experience with insects in science class.

The students then examined what was fictional about the insects: the sizes were disproportionate; all insects have six legs, but some of theirs had two; some of the colors were too bright because insects often have dull colors so that they can't be spotted by predators.

We ended the discussion with two points: reiterating what had been discussed, and stating what had been learned from the discussion. One student remarked, "I learned that you could be a critic without putting anyone down about their bugs."]

Reflection

The fourth graders talked about specific sculptures in a reasonable and natural way. We did not isolate form from meaning: when we talked about volume and color and texture, we related volume to weight and the ability to fly; and we related color to insects' protection from predators. The students saw that color, volume, shape, and other elements of art had practical, meaningful implications for their sculptures. We ended up with a cohesive, coherent conversation built around science and art, and the students were able to provide evidence for their claims about both art and nature.

Throughout this critique, and throughout all critiques, I was thinking on my feet. I was responding to what students said, but trying to keep a line of thought going for as long as possible, and eventually trying to establish a unifying theme for the whole critique. The general theme emerged as design qualities of the sculpted insects.

2.13 Tony Moerch, grade 4, Insect, 1995. Papier-mâché, tempera, cellophane, L: 13" (33 cm).

31

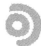 After artists hear interpretive critiques of their works in progress, they can then make important personal decisions about how to proceed further, based on viewers' impressions and reactions.

2.14 Mallory Munyan, grade 4, Self-Portrait, 1995. Pencil on paper, 9 x 12" (22.9 x 30.5 cm).

Changing a Negative Critique into a Positive Critique

Critiques can turn negative quickly. That happened in the following critique, a discussion of five works in progress. The artist of each drawing was asked beforehand for permission to use the drawing (to prevent any possible embarrassment from others talking about how they represented themselves), and was also asked not to talk when his or her artwork was being discussed. Students in this critique live in a mostly white, working-class suburb of Columbus.

Grade Level: 4, 28 students[8]

Artworks: self-portrait drawings, pencil on paper

Duration: excerpts from a 35-minute critique

Leader *What's a self-portrait?*

Hal A picture that you make of yourself.

[The obvious question got an answer in kind, but the class then made a good distinction about kinds of self-portraits when the students said that some were "realistic" and some were "exaggerated." They explained exaggerated by referring to cartoonlike qualities. They spoke about how their self-portraits were realistic and how they were unrealistic, and we had a theme for the critique. From the start, though, the students were quite negative about the portraits, talking about what was wrong with the pictures because they thought that they were not realistic enough.]

Let's get away from all these negative things about the portraits. Remember the question. The question is: How are these portraits realistic?

[The class then compared the drawings to the artists' faces, noting similarities between each drawing and the person. They noted how the eyes were treated,

describing how some portraits had more detail in the eyes than others. Some students noticed hair and how differently hair was treated in the drawings.

By directly noting the students' negativity and telling them about it, and redirecting the discussion toward nonjudgmental observations of realistic aspects of the portraits, the tone of the conversation changed. Often students, especially in critiques that they may assume are supposed to be negatively critical, are not even aware of how negative they are being.]

Toward the end of the critique the art teacher, Ms. Reese, picked a self-portrait by Kenny that she wanted her class to talk about. Some students laughed at it and said that the drawing looked as though he was "retarded." They were again making a negative judgment. We considered why they thought Ms. Reese wanted them to focus on this portrait, clearly implying that she thought it was a good one. This allowed them to get out of the negative reactions and to imagine the teacher's positive response to the portrait. They did well with this question, saying that the portrait was in a cartoon-like style that they recognized as Kenny's style. They agreed that it was good that Kenny had already developed a recognizable style in his art-making. They also noted that the portrait was exaggerated and not realistic, and talked about how it was exaggerated and how it expressed aspects of Kenny's personality through the exaggerations.

Ms. Reese offered that the portrait was perhaps not as unrealistic as they thought. She explained how Kenny had made the picture, remembering that Kenny drew his image based on the likeness he saw of himself in a round mirror. The drawing showed his image reflected to him at an unusual angle. From the explanation, the class realized that the strange angle

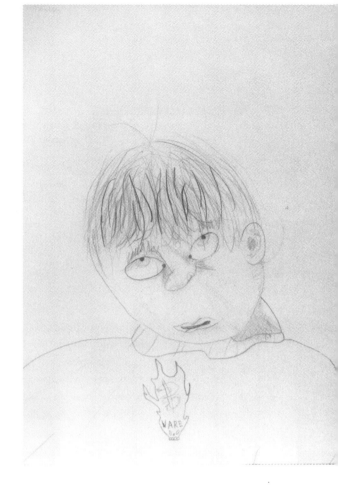

2.15 Adam Woodbury, grade 4, Self-Portrait, 1995. Pencil on paper, 9 x 12" (22.9 x 30.5 cm).

Intervening on behalf of the artist can clarify for the viewers such aspects as the artist's thinking, procedure, techniques, and style. In the art world, critics sometimes do serve as spokespersons for artists, especially when they are under attack and are misunderstood. Teachers can model this practice of critics.

Try This

When students are being overly and unproductively negative during a critique, point out that they are being negative, and redirect questions to elicit more positive answers. Say: Tell me what's good about this artwork. Tell me what the artist has done, not what you think the artist should have done.

Try This

When you are discussing work that you think is good but students disagree, allow them their preferences, but challenge them to think about why others might think it is a good work of art—indeed, a work of art good enough to be preserved, protected, and displayed. Say: You don't have to like this artwork, but why do you think someone else might think that it is good? Can you think of reasons why someone might value this work of art?

accounted for the "retarded" look, and that the portrait was actually more realistic than they had first thought. If Kenny had included the mirror in the drawing, the uniqueness of the angle and the reason for the odd look would have been provided to the viewers.]

Reflection

A crucial moment in this discussion was when the students laughed at Kenny's portrait. Their laugh was negatively critical of the picture. Trying to put the class into the art teacher's shoes to consider why she might value the portrait was a strategy that helped them change from being negative and dismissive to being more thoughtful and accepting.

Inferring Meaning from Drawings

This critique is about fifth graders' drawings of their own houses, from memory. The students look at the drawings for information about the houses and the artists who drew them, and learn that they can infer meaning from what they see in artworks. The questions seek descriptive information, and then inferences about meaning based on that information. The discussion centers around variations of these three questions: What do you see? What might it mean? How do you know? Students in this critique attend school in a rural, mostly white, working-class community.

Grade Level: 5, 26 students[9]

Artworks: drawings of houses (in black pencil, marker, and colored pencils)

Duration: excerpts from a 30-minute critique

Leader *What does Tiffany's drawing show us?* [I selected the drawing because of its many details.]

Kay The house is decorated. It has flowers and color.

[After this good response, and based on it, I redirected questions to get to something else—the artist's feelings or attitudes about her house.]

How does Tiffany feel about her house?

Kay I think she likes it because it is small and cozy. [The generic sequence of questions, which apply to most art—What do you see? What does it mean?—were answered when Kay first told what she saw, and then inferred feeling (coziness) from what she saw. With the next question in the sequence, Sally completed the loop.]

How did she show that?

Sally By having it compact and small and by having it not too wide across.

Good. Let's go to another one. What does this show? [We moved to another drawing to see if other students could infer meaning, as Sally had.]

Holly This one shows that Natalie spent time on showing you how decorated the house was. It shows that she cares about her house and that she likes her house. [Holly made an accurate descriptive observation and then drew an interpretive inference based on her observation.]

How did Natalie show that she likes her house? [This

2.16 *Natalie Nichole Spiert, grade 5*, House, *1995.*
Pencil, marker, colored pencil, 18 x 13" (45.7 x 33 cm).

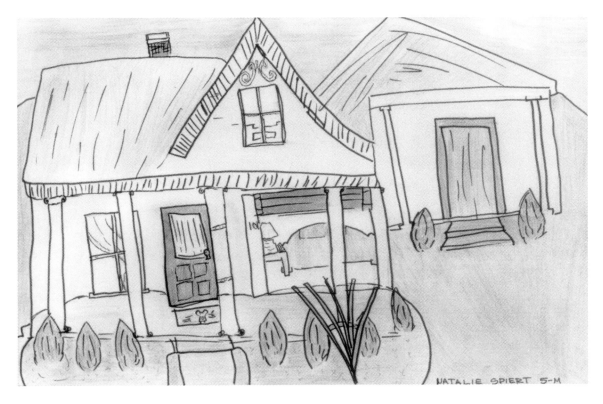

Interpretive questions for all students about all works of art:

(See worksheet 1, page 100)

What do you see?

What do you think it means?

How do you know?

2.17 *Joel M. Studlien, grade 5, House, 1995. Pencil, marker, colored pencil, 18 x 13" (45.7 x 33 cm).*

provided reinforcement for the whole class that Natalie observed, interpreted, and could verify her interpretation.]

Phoebe She could have drew it like real bad and messy but she didn't. [Phoebe provided a good reason for why she inferred that Natalie liked her house—that Natalie had drawn it carefully.]

What can you learn about Natalie's house by looking at this picture? [By asking this question I moved the focus from what the artist might feel, to what the artist actually showed, to what could be learned about her house from her drawing.]

Ray You can see through the window.

Yes. What can you see through the window?

Ray A couch with a table beside it with a lamp on it.

Yes, Natalie made a smart decision. She showed both the inside and the outside of her house. What else can we learn about her house?

Shirley It's an old house. It has gingerbread in the corner.

Jack It's big and she likes it. [Jack returned to inferring about the artist's feelings.]

How can you tell she likes it?

Jack You can tell she likes it because she draws it very neatly.

What does she want to emphasize?

Sally That she's proud of it.

Good. Does anyone else want to talk about another drawing?

Ellen This one. You can tell that she tries to put all that she could into her drawing so that she could show what the whole area looks like. She tried to put as much detail as she liked. And you can tell that she lives in the country because you can see a barn, and it looks like she has a big yard. You can see the

rooster thing [weather vane] on the top.

Very good. [Because Ellen quickly deciphered and accurately described the drawing, the discussion moved to another.] *Does anyone want to talk about this one by Joel?* [Joel's drawing was formally different from the rest of the drawings.] *What can we learn about the artist, or about the house that he lives in?* [Here the students had the option to infer about the artist's feelings or to find information about the house itself. These students were easily moving between the two topics.]

Fay That he's got a big house and a big yard and flowers.

Hillary That his house is a lighter color.

How does the artist feel about his house?

Hillary He feels great because it is his house. [Hillary assumed that Joel felt great about his house just because it was his house. I asked for evidence in the drawing.]

But how can you tell?

Sydney It has lots of stuff and attention to detail. It has lots of flowers. In his yard, he put everything in. He's not skipping anything. So that he can get in as much detail as he can.

Scott He wants to put all this stuff in, and he's really concentrating to show everything. [Sydney and Scott sensed a commitment to the house from the way the artist made the drawing of it, and they made a good inference.]

He chose to make his different from, say, this one above it. What choices did he make to make it different from others? [Joel's picture stood out as innovative.]

Scott It's close up. He drew it closer up than the one that's above it.

Was making a close-up a good choice? [I wanted to emphasize that Joel made a choice, that it was a different choice from what others had made, and that choices made by an artist in an artwork have consequences for the viewer.]

Scott Yeah. It shows lots of detail.

Reflection

My purpose for the students was twofold: as viewers, to look carefully at drawings, think about them, and then infer how the artist felt about what he or she had drawn; and, as artists, to communicate effectively to their peers about their house through their drawing.

I had to remind the students to look, describe, interpret, and provide reasons for their interpretations. They quickly caught on. We did not always first describe and then interpret. We did both together and switched back and forth between description and interpretation. Sometimes I began with an open question (What does Tiffany's drawing show us?) that could elicit either descriptive or interpretive information. In general, description should be motivated by larger interpretive questions. We describe to interpret, and we offer descriptive evidence to support interpretations. Description and interpretation are intertwined. To describe without having interesting interpretive questions follow can be tedious for both students and teachers.

Ms. Groendyke's instructional goal was to have the students experience the differences between drawing from life and drawing from memory. The critique could have explored and reinforced differences between drawing from sight and drawing from memory. The same group of art objects could likely support critiques centered around different objectives.

Aesthetics in an After-School Art Program

This critique is included to show that successful discussions of art can occur in diverse locations and with mixed age groups of young artists. It also shows how a discussion can move naturally from talking about specific artworks to talking about philosophical concepts; in this case, skill and imagination. The critique is an example of how the activities of art-making, art criticism, art history, and aesthetics can be interwoven.

Grade Level: ages 7–13, 8 students[10]

Artworks: athlete-warriors, mixed media

Duration: excerpts from a 60-minute critique

The students involved in this critique are participants in an after-school program that includes visual arts. This was a voluntary program sponsored by a metropolitan Boys and Girls Club, and there were other activities in the center competing for the children's attention, including games in the gym.

Under the direction of the artist-teacher, Mr. Bernstein, the students had completed artworks based on the theme of athletes as warriors. As motivation and inspiration, the students had studied games of indigenous cultures, such as those from the Plains Indians, the Maya, and the Hopi. One goal of the project was to teach the students to direct their "warrior" needs toward positive ends.

The children's athletes-as-warriors artworks were displayed around the room and included freestanding sculptures of energetic dancers, drawings of athletes, and paintings of football players in uniforms and helmets.

Dimitri How long is this gonna take?

Leader *About a half hour, but any of you can leave any time you want.*

[My answer seemed to reassure Dimitri and he enthusiastically entered the discussion. We began with eight children participating; two children drawing in the back of the room chose not to participate, and other children came in late and entered the discussion. In describing a black-marker drawing of an expressive but vague figure by Marisa, age 9, the students readily made connections to their natural environment, where large cacti are indigenous.]

Kelsey (age 8) It has poky things all around it, like a cactus. It looks like a referee because it has stripes on it.

Dana (age 12) It looks like a human cactus.

Kelsey It looks like a walking monster cactus.

[The discussion moved to two paintings based on football. Dana (age 12) and Lauren had collaborated on the picture, which was well rendered, with some perspective, foreground of a grass field, middle ground of players in action poses, and a background crowd of blurred faces. The students analyzed the painting and then compared it to another football painting, by Nicholas, age 8.]

John, what do you think?

John (age 10) The one that Nicholas did has more solid colors.

What do you mean?

John Most of the players are wearing the same colors and patterns of uniforms, and the one that Dana did has more random color patterns.

Random color patterns! That's interesting. Where do you see the random color patterns?

John Like on the players' helmets, in the lower right, and on the jerseys.

[The students agreed that both artworks were good paintings. Later, we made analytic comparisons of

2.18 *Dana Hogue and Loren Alberico, ages 12 and 11,* Football in Action, *1995. Tempera on cardboard, 3 x 3' (91 x 91 cm).*

the two football paintings and which was more realistic and which more expressionistic. Nicholas's painting was imaginative, with some players upside down and others suspended in the air.]

If you only had one blue-ribbon prize to award, which painting would you give it to?

Alison (age 9) I'd give it to Nicholas's because of the nice and creative job that he did.

John I'd give it to Dana and Lauren's because it reveals art talent more than creativity. [With this, John had suggested a philosophical distinction in support of his artistic judgment. I decided to encourage a philosophical discussion of imagination versus skill.]

You seem to be responding to the skill Dana and Lauren's picture shows. [John nodded in agreement.] *Is skill better than imagination, or is imagination better than skill? Which would you rather have, skill or imagination, or would you want to have both?*

John Probably skill.

Why?

John I don't know. I just rather take that over imagination.

Alison Imagination.

Why, Alison? Tell John why imagination is better than skill.

Alison Well, because when you have imagination,

you don't have to worry about how it looks, you just use it as if it were you and your friends out there doing something.

[John wasn't persuaded by Alison's reasons.]

Mr. Bernstein You've got to have both. It starts in the head or the heart. A feeling, an idea. It can be from the brain, or it can be just an emotion—happy, mad—and then it's up to Mr. or Ms. hand to join the head and make the art. Because you're making art, your head has to tell your hand. If you had this great drawing hand that just did draftsmanship—great drawing all day—and never had an idea, I don't know if that would be a very happy way to be. But if I had a hand that had some imagination, and could put things together, I think that would be the best.

Reflection

This critique, like those in schools, shows that students enjoy talking about art and have interesting, informative things to say about it. The discussion

2.19 Nicholas Andres Rodriguez, age 8, Nicholas' Football, *1995. Tempera on cardboard, W: 2 1/2'* (76.2 cm).

met the objectives—to empower the students with art experiences and help them turn their energy to positive outlets. The critique demonstrated the ease with which young artists can move among and talk about art-making, art criticism, and aesthetics. When asked to judge between two good football paintings, John asserted that he valued one over the other and he offered a philosophical justification, namely, that one revealed "art talent" and was better than the other which showed "creativity." I recognized that this statement could be furthered into a discussion of aesthetics concerning skill versus imagination. The children had no problem philosophizing about the issue and their teacher readily joined in. In this lesson, the children moved fluidly from art history (Mayan, Hopi, and Plains Indian influences) to art-making, to criticism, and finally to aesthetics.

Interpreting the Teacher's Art

A teacher's art is the stimulus for this critique, a critical discussion with high-school students in a beginning ceramics class. The teacher is an exhibiting artist and teaches her classes much as an artist might, sometimes working alongside the students in communal fashion. This critique gave the students the opportunity to critique the work of a professional artist.

Grade Level: mixed, 10–12, 25 students[11]

Artworks: ceramic sculptures

Duration: 50 minutes

The class was divided into five groups, and each group studied one of the sculptures for about ten minutes. Individuals in each group, in turn, told about the piece their group had examined. The following is a discussion of the sculpture pictured on page 42.

Although the artist was present, the students were asked not to direct questions to her. The critique was to be of the artist's work, not the artist. One of the goals of the critique was to let the students know that no one—viewers, critics, or the artist—holds the single, correct interpretation of an artwork.

Leader *Okay, let's describe the sculpture. It's small and very complicated and we can't see it very well, so you're going to have to be very descriptive. Natalie?*

Natalie It's sort of like a pot in the shape of a face. There's a mouth cut out so it's hollow inside. There's a tongue in there, and people in there, little figures of people inside its mouth. People are pressed into the sides. There's a lid on top that has writing on it. It says, "They gathered together by the fire" over and over again.

Who do you think "they" refers to?

Natalie The little people.

And how many are there?

Natalie There's some people on the back, too.

So lots of people. At least six, maybe ten? I'm sort of directing you. [The directing was to get Natalie to be more specific and descriptive. She needed coaching, much as some of the second and fourth graders had needed, because this way of talking about art was new to her, and she had yet to acquire the skills to describe art.] It has an inside and an outside, right?

Natalie Yes.

Let's start with the outside. Tell about the outside; then we'll go into the inside.

Summer On the outside, you can barely make out the eyes, but you can see them. It looks like she's screaming. Her eyes look all nervous and broke down.

2.20 Peggy Jo Sivert, Untitled, *1995. Stoneware, H: 12"
(30.5 cm).*

Try This

Invite the students to write about art.
Ask them to write descriptive, interpre-
tive, and evaluative paragraphs about
an artwork of their choosing.

Natalie, you're indicating there's long hair.

Natalie Yeah. There's long hair.

Summer Where?

Natalie There's long hair here in the back where hair
is supposed to be.

Summer It's not hair. Those are people.

Natalie It's people that's shaped like hair. [This is an
example of two descriptions being better than one.
Both descriptions are complementary; neither one
alone would have been sufficient. More than one
point of view is an advantage of group discussions
about art.]

Okay. So we have hair shaped like people.

Summer People in hair, and it looks like a girl's, but
it looks like she's depressed about something, like
she's sort of punching holes in it.

*And when you just said "she" now, you're referring
to the artist?*

Summer Yeah. It's the artist. It's like, she, the artist,
was scraping and scraping because either the artist
felt like it or something was making her mad, so the
artist is kind of cutting at the clay.

*Good. That's important. I'm going to interrupt you
and interject that how the artist uses the materials is
very important. I think you're right. How the artist
used the clay does look very emotional. It's not real
smooth; it's not real finicky. It's very emotional. How
the artist treats the materials is very important. Lisa,
tell us about the inside.*

Lisa The inside looks basically hollow. There's a
tongue, and there's people inside also. To me, they
look like they're coming from the inside out. Maybe
other people see it differently. It looks like the peo-
ple are coming from out of the head.

Okay. Good.

Natalie To me, it looks like there's people who are actually trying to get in there. They're trying to get into the inside. It looks like they're holding the mouth open and trying to get in, and it looks like people are, like, crawling around.

Okay. Kerry?

Kerry I kinda disagree. It kinda looks like she's screaming, and all these people are, maybe, voices or feelings, in the shape of people, and they are trying to get out.

Yes, Barbara?

Barbara That's what I was gonna say.

Say it again. Say it in your own words. [Sometimes, students think that their thought has already been said by another, but it is actually a different thought that builds on the prior thought.]

Barbara Yes, it's like people in the mouth are holding the mouth open so everything will come out, kind of like guilt or something, that's trying to scream out.

Natalie But the people inside are sitting down.

And what does that indicate to you? [It's important to ask the interpretive implications of descriptive comments: The people are sitting (description), but how does that affect the meaning of the piece (interpretation)?]

Natalie They've already gotten in.

They've already gotten in. And they're staying?

Natalie Yeah.

Barbara Well, it kind of looks like, in the back, that these people are trying to get out, and then these other people are trying to get in, like they're crawling closer and closer to get in, and these people are trying to hold the mouth open.

Okay. Good. By the way, you shouldn't handle art that someone else has made. If this were in a museum, we wouldn't be handling it. We might drop it or break it. So we're trying to be very careful. [That all art, especially art in a museum, cannot and should not be handled is important for students to learn. How to behave in the art world outside is part of the learning inside the art classroom.] *Other observations? Questions?*

Amy Well, are all these people in the head, problems inside this person's head? Maybe all these problems are festering, and some of them have gotten out, and some of them haven't? [Amy directed her interpretive questions to the group, rather than to the artist.]

What do you think about that interpretation?

Barbara Yeah. I agree with it.

Natalie Yeah.

They like your interpretation, Amy. Kerry?

Kerry The people inside might be the person's, the artist's, thoughts, thoughts that she might not want to release. Like the good feelings of love and all that stuff. Maybe she was trying to keep them there.

Oh, that's interesting. So, some she wants to keep; others she'd like to dispel? That's interesting. By the way, we're making a jump, and we're assuming that the artist is making an expression about herself. That's not a safe assumption. Correct? She could be talking about someone else. We don't know. These works of art could be self-portraits, or portraits of someone else, or imaginary. We don't know. [The aim of the critique was not to have the students psychoanalyze the artist, or to think that they had uncovered actual secrets about the artist. Rather, the goal was for them to decipher what they thought the artwork itself was about, realizing that it might

be about the artist. A critic's job is to criticize art-works, not artists.] *I thought the words on the piece were really compelling. Do you remember what they are?* [Moving the students to a different aspect of the piece was to keep their attention on it.]

Natalie It says, "They gathered together by the fire."

"They gathered together by the fire. They gathered together by the fire. They gathered together by the fire." It keeps going. It's in a spiral. Why is that? It seems like a pretty important part of the piece. Any thoughts on that?

Barbara Maybe they're trying to get in for warmth.

Natalie Exactly.

Okay. Warmth. Other possibilities?

Ian Maybe it's cold in there, and they're trying to get out.

Maybe. That's interesting. [Pause.] *How do you know that the fire inside is welcoming, or is it hell? I mean, is it warm and drawing people in, or is it hot and they want to get out?* [These questions were to show more than one interpretive possibility and to encourage the class to think more before they moved on.]

Kerry I think they want to get in.

Okay. And how do you know that?

Natalie Well, because all the people are sitting around the tongue area, and it looks like all these people are trying to crawl through the mouth to get in.

Amy I think it's people gathering together around a fire, like the big head might represent a leader or something, and all these people are gathered here, and it might be like a cult or something. Some people are trying to get out, but others are trying to get in.

Reflection

Before we had finished talking about the sculpture in this part of the larger critique of the other works, I picked up on and talked about considering a spiritual theme. There was no response to this probe, so we went on to another work. I felt that if I pushed the moral concerns here, I would have to tell what I thought rather than leading the students to make discoveries they were already close to making. Later, we did talk about the moral values implied by the artworks. If I tell students my interpretations, and sometimes I do, then they may learn more about the artwork and how I think about it, but they do not have the challenge and opportunity of making interpretations themselves, and to learn that they can offer insightful interpretations.

This critique is an example of a good interpretive discussion. The students built upon one another's comments. Sometimes they had different observations and disagreed with one another, but they did so in a friendly, noncompetitive way. The group worked for some consensus. The students made observations and then drew some tentative conclusions about such facets as the people in the sculpture, the way the artist manipulated the clay, and the possible religious and spiritual connotations.

Conclusion

This sampler of critiques disputes the notion that students are not interested in thinking and talking about art and that they want only to make art during art classes. The students showed that they are also interested in deriving meaning from their art when given the impetus and direction by someone who facilitates their thinking and talking.

Students as young as kindergartners can success-fully talk about art of their peers and of older stu-

dents. Students are curious about and can discuss art that other classes of students have made. Multi-age groups learn from one another's art: second graders can learn from kindergartners, and high-school seniors can inform freshmen and sophomores. Students can learn from their teacher's art, and their teachers can learn about all art from their students' insights. Learners can be engaged in whole-class or small-group discussions, and in individual writing about works of art.

Students can derive meaning from artworks generated through typical art lessons—lessons about clowns, Picasso, batiks, self-portraits, and ceramics. Teachers who want to add more criticism and aesthetics to their teaching do not have to develop a new curriculum; they can build on what they are already teaching. An art specialist might work collaboratively in critiques with a classroom teacher or teachers.

Critiques can be built around the instructional goal of an assignment, or might concentrate on other areas of concern. Critiques can be used to assess teaching and learning. They can include historical references. They can flow from talk about specific artworks to discussions of bigger philosophical ideas.

Most of the discussions in this sampler were conducted with students who were just getting started in this kind of thinking and talking in art classes, yet they had thoughtful ideas about art. Imagine the conversations students could have if they were taught not only to make art, but also to talk and think and write about art throughout the school year, through their senior year, and beyond.[12] Imagine, too, how much their art-making abilities might improve with this kind of consistent and persistent thinking about the art that they and their peers make.

Notes

1 Pamela Reese, art teacher, Longfellow Elementary School for Math and Science, Westerville, Ohio. Most students in this suburban school district are of Anglo descent and of middle- to upper-middle-income families.

2 The teacher and school in this critique wish to remain anonymous.

3 Rebecca Hartley, student teacher, Department of Art Education, Ohio State University. Thomas Elementary School, Dublin, Ohio. Dublin is a small upper-income city outside of Columbus. The majority of the population is of Anglo descent; the minority, of Japanese descent.

4 Lori Groendyke, art teacher, Harrison Street Elementary School, Sunbury, Ohio. Sunbury is a rural, white, working-class community.

5 Linda Chapman, second grade teacher; Toby Rampelt, kindergarten teacher; Pamela Reese, art teacher; Huber Ridge Elementary School, Westerville, Ohio. Most students in this suburban Columbus school are from white, working-class families.

6 See note 4 above.

7 See note 1 above.

8 See note 5 above.

9 See note 4 above.

10 Judy Butzine and Howard Bernstein, cofounders of ArtWeb in Phoenix, Arizona. Ms. Butzine coordinates the program, and Mr. Bernstein is an artist who teaches in it. The program is sponsored by the Boys & Girls Clubs of Metropolitan Phoenix.

11 Peggy Sivert, art teacher, Costa Mesa High School, Manhattan Beach, California. Manhattan Beach is a primarily white, upper-middle-class community.

12 Michael Parsons, *How We Understand Art: A Cognitive Developmental Account of Aesthetic Experience* (Cambridge: Cambridge University Press, 1987). Parsons describes the levels of understanding of art that young people and adults can reach. His explanations are based on one-on-one interviews with viewers of different ages about preselected paintings. The conversations in *Talking About Student Art* are similar to those in Dr. Parsons' book.

Chapter

3

Interpreting Student Art

Teaching students to interpret art is the central activity of art criticism. Without interpretation, an artwork is a mere thing, not an expression.[1]

content = subject matter + form

Criticism does not need to follow the order of describing (and describing only what is seen in the work and not applying relevant knowledge to the work), analyzing form (apart from subject matter), interpreting, and judging. Criticism can be much more fluid than this and can provide answers to questions such as: What does this artwork express? What does it imply about the world? What would this artwork have me believe? Is the artwork for or against something?

Try This

Key issues in art philosophy are artists' intentions and their importance to understanding works of art. Use this topic for a discussion of aesthetics with middle and high school students. What do your students believe about these issues? How can you help students discover what they believe and how to identify and articulate their implicit assumptions?

Interpreting an Artwork: What to Ask

To interpret a work of art is to answer these questions: What do I see? What is the artwork about? How do I know?

What Do I See?

To answer this question, the viewer must describe what he or she is looking at. This means describing the subject matter and use of media and form. The viewer can also describe things referenced by the artwork. For example, in the following critiques, students mention soccer, Easter Island, and origami. If the viewer is unfamiliar with such things in the world outside the artwork, he or she would not know how to interpret them in artworks.

What Is the Artwork About?

Description of an artwork should be motivated by this question. Description and interpretation are simultaneous, interactive, and constructively circular, something akin to reading a sentence. To read and understand a sentence, we need to know the meaning of the individual words, but these words have meaning in relation to the sense of the whole sentence. We describe to interpret, and we interpret based on descriptions of what we see. Descriptions in the critiques in this book are motivated by interpretive questions (What does this express?) or evaluative questions (How is this work good?).

Telling what an artwork is about entails finding the relationships among the subject matter, uses of media and artistic technique, and form—all to identify the content of the work. The content is not the subject matter (a soccer ball, for example); it is how the artist used materials and technique to form the subject matter.

How Do I Know?

This question seeks evidence and reasons for interpretations, which usually come from what the viewer can directly observe in the work, and from what he or she knows about the world and the time and place in which the artwork was made. Providing reasons for interpretation prevents accepting any and every thing someone might say about an artwork. Some interpretations are better than others because they have more evidence, and are more convincing and enlightening. Some descriptive observations are faulty (the subject may be a goat and not a unicorn); therefore, the interpretations built on them are likely to be flawed. Good interpretations are those that accurately reflect what is in the work and what brings life to it; they reveal to viewers what there is to consider about the work, and engage others in informed thought and discussion about art and life.[2]

The critiques in this chapter reveal that artworks are often different from the teacher's intent in assigning a project, and the student's intent when making the artwork. The artwork does not always mean to others what the artist had wanted it to mean. Rather, the viewer constructs meaning based on what he or she sees and knows.

Artist's Intent and Viewer's Interpretation

Does an artwork mean what the artist meant it to mean? Does it mean only that? To understand a work of art, does the viewer need to know what the artist wanted to express? These philosophical questions raise important issues in art.

Some artists choose not to talk about the meaning of their works. When an artist does say what he or she wanted to express, that explanation is an interpretation, one among other possible interpretations, and not necessarily the best interpretation. A critic may be more articulate about a work of art

Some relevant questions about artistic intent:

- Can we know an artist's intent? Ever? Always? Do some artists work intuitively, drawing on the subconscious, and even intentionally block specific intent?

- Is an artist's intent, when available, always relevant to the meaning of the artwork?

- Can an artist mean to express one thing, but then express more than that, or something different from that?

- Should the artist's stated intent be the final arbiter when determining the accuracy of an interpretation?

- As a teacher, what are your beliefs about artistic intent? Are you consistent or contradictory when you teach about artistic intention, art-making, and art interpretation?

than the artist, and a student viewer may be more insightful about another's work than the student artist.

Having student artists tell in words what they meant to express teaches them to be dependent on artists for interpretations, and will not encourage them to interpret art for themselves. To interpret artworks and other kinds of expressions, students need practice and guidance from art teachers. The teacher also is responsible for teaching students to have artistic intentions—good ideas—when they make artworks, to generate good ideas for art-making, and to express those ideas effectively in media. Students benefit from considering intent, the worthiness of the art, and whether they effectively fulfilled it in shaped media that others see.

Some theorists hold that an artist's intent is irrelevant to the discussion of artistic meaning because we can't really know an artist's intent; an artist may intend to express one thing but actually expresses something not intended; artists may not have or know a specific intent; an artwork may express more or less than what the artist intended; an artist's stated intent, when available, might limit interpretations.

Interpretation When the Artist Is Present

Asking questions of an artist present during a classroom discussion about his or her work is often a shortcut to interpretation, which weakens interpretive exercises. Artists are not generally available to answer questions about their artwork; therefore, if an artist is present, he or she best serves the students by listening and remaining silent, putting the sole responsibility on the viewers to decipher the work of art. The artist who does not have to defend the artwork may better understand how viewers respond to it.

Discussing the work of artists who are not members of the art class ensures that viewers cannot rely on the artist for interpretation. Outside the classroom, artists are not usually present during discussions of their work.

Four Interpretive Critiques of Inside-Outside Boxes

The following critiques involve stated intents, but do not rely on the artist for the "right" interpretation. Students consider and then accept or reject the artist's stated intention. The responsibility for interpretation rests with the viewers; the responsibility for clear expression in media, with the artist.

All the critiques show different ways of engaging students in interpretive discussions about artworks. The critiques are with different groups, but are all based on the same project.

Background of the Studio Activity

An educator and self-taught artist in Ohio,[3] Jann Gallagher takes small wooden or plastic boxes and paints, carves, and collages them with words and pictures, transforming them into personal artworks. Based on these boxes, she designed a studio activity for third and fourth graders. She presented herself as a visiting artist, showed the students her boxes, and asked them to make their own.

To get the project underway in one class, the artist passed some of her boxes around for individual viewing. Then she held up a gray box covered with lines and words. On its sides were glued a small crutch, a tiny cane, and a miniature stop light. The top of the box was covered with a magazine photograph of an elderly person.

Ms. Gallagher told the students, "I've been thinking lately about the way people see me. I think peo-

ple see me as an old woman. I painted this box gray because I think that the first thing people see when they look at me is my gray hair. I found a magazine article titled 'You're Too Old.' I took the big title from the article and glued it on top of this picture of an old person. Then I put smaller titles of 'You're Too Old' on the sides of the boxes. Next to each title, I glued a small item that I thought represented being old. I also wrote comments that people have made to me recently that have caused me to think that I am getting old. The text around the little crutch reads, 'My sister looked with horror at my skates. You're too old to roller blade!' Near the cane, I wrote what someone else told me: 'You're too old to be pretty.' How I see myself is very different from how these people see me."

Then she opened the box. The inside was painted bright red and yellow. Glitter and sparkle decorated the walls. A rhinestone pin was in the center. In front of the pin on a pedestal made from a film spool was a shapely exercise doll with hands on hips and one leg kicking out. Around the central figure were a miniature lipstick, a pair of sunglasses, a tiny toy roller skate, and a small tube of paint. A little plastic ladder stretched from the base of the box up toward the rhinestone pin. After the students discussed the items in the box, Ms. Gallagher asked that each student make a box of his or her own. The artist told the class, "The idea is to first think about how people see you. Put that on the outside of the box. Then think about how you see yourself. Inside-outside! Get it?"

After the artist's presentation, each teacher gave more specific instructions to her students.[4] One teacher had the students make their boxes during class time. The others gave a deadline and had the students work on the project at home. Students attend school in a racially diverse, working-class town

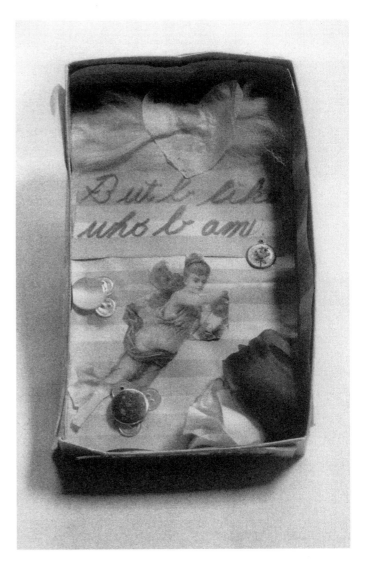

3.1 Lori Leppelmeier, grade 3, Inside-Outside Box, 1995. Mixed media, 8 x 4 1/2 x 1 1/2" (20.3 x 11.4 x 3.8 cm).

The use of the folded paper about viewer's understanding and artist's intention works in small groups as well as with individuals. In one critique of inside-outside boxes, three fourth graders used the folded paper to work together to interpret one box, and they came up with more information than any one of them likely would have alone.

Have students use worksheets 2 and 3 (pages 101, 102) for activities about the artist's intent and the viewer's response. Then use the sheets as a starting point for large-group discussions.

outside Cleveland. About a month later, the critiques were conducted. Descriptions of them follow.

Critique 1

In a fourth-grade class, each student was given one inside-outside box, but not the box he or she had made. Each student folded a piece of notebook paper in half, making two columns. In the left column, they listed what they thought the artist was expressing about himself or herself. First they made a list of ideas they got from the outside of the box; then they made a list of ideas from the inside. They left the right-hand column blank. For example, to describe the outside of the box she had been given, Elise wrote, "She's a good friend, smart, excitable, bright." For the inside, she wrote, "She's pretty, sensitive, nice, smart."

The papers were then folded so that the comments could not be seen. The students were given the paper for their own artwork, and wrote in the right-hand column what they had meant to express. For example, when Jeanine got Elise's folded paper, Jeanine wrote, "I was trying to make people think outside I had a sparkling personality. Inside, I am plain, sensitive, nice, no glasses, smart." Elise's interpretation matched Jeanine's intended expression. The skills of both the artist and the viewer were reinforced: the artist, Jeanine, had clearly expressed what she wanted to; Elise, the viewer, was able to decipher Jeanine's expression.

Critique 2

In this exchange, there were some differences between intent and interpretation. Dan, the viewer, wrote, "Outside, I think Joe likes himself and is proud of himself about some things. On the inside, I think Joe likes animals." Joe, the artist, wrote, "Outside, I have bright ideas. I'm cool, I'm creative,

I'm nice, and I'm proud of myself. Inside, I like sports and animals." Joe's ideas were more specific than Dan's abbreviated reading. This may have been because Dan didn't carefully decipher what was there, or Joe didn't communicate sufficiently with the images and words he used. Dan could then consider whether he was a careful enough observer, and Joe could consider whether he should have made his box differently.

Critique 3

In this analysis, there is greater discrepancy. Tara interpreted the box that David had made. She wrote, "On the outside, soccer is a favorite thing." David wrote more specifically about his intent: "I put the soccer ball and the bright colors on the outside because that's how people see me on the outside." Tara's and David's understanding of the outside were compatible, although David's offered more elaboration. About the inside, however, there was clear miscommunication. On the inside of his box, David had pasted a magazine photograph of a refrigerator with an open door. In the refrigerator was a cake. Tara's reading was that the artist's "favorite thing is cake." David, however, meant to express, "I love playing with machines." He chose the refrigerator and meant it to signify a mechanical device, but Tara and the rest of the class saw the refrigerator as the holder of what seemed to be important to the artist. This miscommunication was beneficial for the artist and the viewers. Later, David said that he wanted to change the inside image and find something that would more clearly communicate his enjoyment of playing with machines.

Critique 4

Another successful critique occurred with a class of third graders. Lori had covered the outside of a box with a piece of white paper and had written "boys" lightly in pencil. The sides of the box had vertical stripes of crayon, over which were penciled sentences: "At restaurants, waitresses call me 'young man.' New kids think I am a boy. At stores, people think I am in the wrong section. My brothers tease me and call me boy names." The inside of the box had a paper heart pasted over yellow, pink, and blue yarns; pink, blue, and white wrapping paper; glued buttons; a stick pin with a flower; two silk roses; and a magazine picture of an angelic-looking girl in flowing Grecian robes. In the inside, Lori had written, "But I like who I am!"

From examining the outside of the box, the class was intrigued by who the artist might be. They wondered if the person was happy or sad about being mistaken for a boy. They speculated about how she could look more like a stereotypical girl if she wished to, and reasoned that she must not be too uncomfortable, since she probably could change her appearance if she wanted. When they saw the inside of the box, they were pleased to see that the artist was content with the way she is.

Outcomes

These interpretive activities do not place sole responsibility for effective expression and communication on either the artist or the critic. They demonstrate to the artists that they have the power to communicate, sometimes specifically, with their use of images and words; and also that they might miscommunicate through their art-making. If artists don't choose the right means of expression—no matter what they intend to express, or how much they want to express it—their viewers will not be able to decipher the intended meaning.

Critics and viewers benefit from this experience if they learn that they can decipher another's meaning

by looking carefully at art objects and thinking about what they mean. They might also learn that they have not looked carefully at an object, that there is much more there to be seen and understood.

Deciphering Irony

Some students used sarcasm in the design of their inside-outside boxes, which presented an important interpretive problem—whether interpreters should understand the words and symbols on the box literally or as though they were being presented sarcastically or critically. For example, on the outside of her box, Stephanie had these words: "Barbie, get real." Some students thought that "get real" indicated that Stephanie was being sarcastic; others did not understand that she was being sarcastic and were confused by her expression. After Stephanie heard the discussion, she decided to change her box so that her meaning would be more readily understood by viewers—she did not like Barbie.

Asking whether an artwork's expression is sarcastic, ironic, or critical of something is essential. The viewer must ask, "Is the artwork praising or condemning that which it is showing?" Many artworks condemn what they show; to fail to realize that they are negative expressions is to misunderstand them. But expressions of sarcasm, irony, or disapproval in an artwork are not always apparent.

Some of Claes Oldenburg's sculptures and proposed sculptures raise the issue of deciphering intent. Oldenburg once proposed a sculpture to be placed on the Thames River. The sculpture was to be the floating mechanism in toilet tanks. The sculpture, clearly and reasonably enough, can be interpreted as a criticism of the dirty water of the Thames. Other Oldenburg sculptures, however, are more ambiguous. Deciphering the intent of his famous stuffed-canvas French fries tumbling from a bag suspended

3.2 Sarah J. Krause with her Inside-Outside Box.

from a museum ceiling is a harder task. Is the artwork celebrating the abundance of fast food in our culture, or is it a criticism of a wasteful consumer society that floods the market with junk of all kinds, including junk food? Answering this might involve looking at other Oldenburg sculptures from the same period, and reading what critics have written about them. However, merely asking the question is important. Doing so avoids drawing a hasty interpretation. Artworks are rarely neutral—they are usually for or against something.

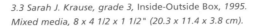

3.3 Sarah J. Krause, grade 3, Inside-Outside Box, 1995. Mixed media, 8 x 4 1/2 x 1 1/2" (20.3 x 11.4 x 3.8 cm).

all of these ques-

artist is for or

...al, religious, or racial
views does the artwork seem to
uphold?

- What would this artwork have you believe about the world?

- Does the artwork represent a male or a female point of view?

- What does the artwork assume about the viewer?

- Is the artwork directed at a certain age group, a certain class of people?

- Who might most like this artwork?

- Might some people be offended by the work?

Media and Meaning

Painting is stronger than I am—It makes me do what it wishes.

—Picasso

Picasso here refers to the power of any particular medium to affect how an artwork will look. As Michael Parsons has explained, media and materials have expressive properties of their own, independent of what the artist may mean them to have.[5] If an artist like Picasso cannot control every aspect of his medium, then students learning art will have considerably less control. Van Gogh's *The Starry Night*, painted in thick, heavily textured oil paint would have a different effect if it had been painted in thin, transparent watercolors. Michelangelo's marble *Pietà* would have different expressive qualities were it made of brightly colored plastic.

Teachers must instruct art students how to choose media wisely and how their use of a medium affects what the work expresses and how it does so. Media affects meaning, no matter what the artist intends. For example, while interpreting an inside-outside box made by a third-grade girl, the class could not decipher what the artist may have meant by a drawing and words on the inside cover. After a lengthy try, they sidestepped our rule and asked the student artist what she wished to express. She said that she hadn't meant anything by it; she used the paper only to cover up the cellophane cover, and the paper she used just happened to have a drawing and words on it. From the discussion, she understood that she had unintentionally misled the viewers. A different but related problem emerged in the following discussion.

A Media Critique of Inside-Outside Boxes

For their inside-outside boxes, a fourth-grade class used thin, flexible white opaque plastic boxes from a

hospital-supply store. Renee, the artist of the box discussed, had painted the outside of the box with purple tempera paint. Because the tempera did not adhere to the plastic, the outside surface of the box was flaky and scratchy.

Leader *Do you think Renee wanted the piece to look the way it looks on the outside?*

Beth Maybe. Instead of writing on it, she just engraved it.

What about the outside cover and the sides of the box? Did she want the paint that way?

Beth Yes.

And what is she expressing by doing that?

Beth Purple is a bright color, so she's saying that she's bright. [Based on this answer, the next question had to be narrower in scope.]

Yes, but I'm concerned about how she applied the paint and if that means anything to you. How do you think she applied the paint? Why does the paint look the way it looks?

Beth Everybody's going to be looking at it to see what the people are on the outside and on the inside. [This did not answer the question.]

Do you think she washed some of the paint off or not?

Beth No, because there's like smear marks; there's fingerprints.

Do you think she would have preferred to have the paint smooth and not falling off, or do you think she prefers it just the way it is?

Beth Maybe she would prefer it smooth because smooth is like smart. Smart people don't act crazy. If they're smart, they're very smooth and soft. [Beth had arrived at a conclusion with reasons. Renee

acknowledged that the paint flaked off ac[...] and that she had wished it would have stayed o[...] and been smooth.]

Okay. Renee just told us that she had a paint problem, that the paint flaked off. You're right, Beth. Renee would have preferred to have the box nice and smooth, but it's flaking off. This is an important point. If we didn't know that she had a paint problem, we might think that she made it to look scratched and flaky, and that would communicate something to us.

[The next box raised a similar issue. The artist had done very little; there was almost nothing on the outside of the box.]

Here is another box. What does the way this box is made tell you about the person who made it?

Kelly Nothing.

Nothing?

Kelly Not really. It doesn't have anything on it.

Doesn't that tell you something?

Cathy Yes. The person stays to themselves a lot. They are not very open. [Cathy got the point that having little or nothing did express something, and she suggested a possible interpretation.]

Yes, good. The point is that the way a box is made communicates something. You gave me a good answer, Cathy.

[When discussing a different box, Sally offered chipped paint as a point of interpretation.]

Sally Because this person writes "bad" on the box, I think they get in trouble a lot. And the paint is all chipped off.

But remember, we know that the paint chipping off might be a technical problem and not an expressive property. Here it's merely a technical problem. If they

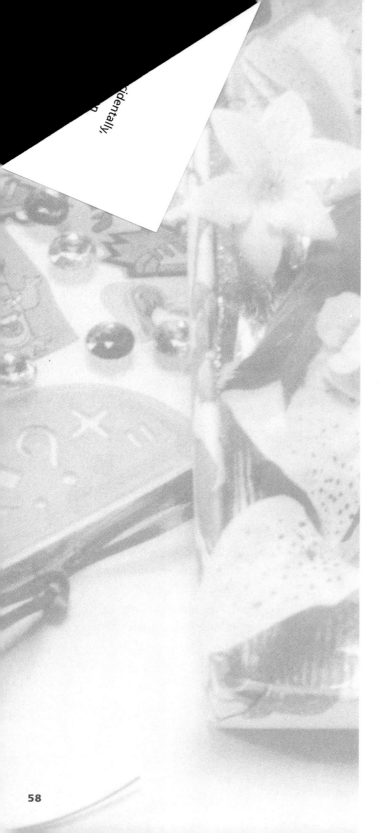

had better materials, they would have gotten a more accurate box. But we have tempera paint on plastic, and tempera paint doesn't stick to plastic. If the artist did it again, he or she would use different materials. That's important to figure out though, right? Because I could misinterpret this box, I could misunderstand this person. I could think that this person is not very careful or that this person is angry. That would be a wrong interpretation, because it's just that the paint didn't stick to the plastic. [When students make mistakes or have technical difficulties with media and materials, it is important for both students and teachers to decipher that these are mistakes rather than intended expressive treatments of materials, and also to realize that materials, in themselves, have expressive connotations.]

Gender Stereotypes

Art viewers sometimes attribute gender to an artist of a particular artwork, usually based on stereotypes, without actually knowing the artist's sex. This, along with other attributions of masculinity or femininity, warrant discussion and clarification in order to produce less biased interpretations.

A Critique with Gender Issues

The following critique is an interpretive discussion about inside-outside boxes that fourth graders had made. Each student was given a box that was not his or her own. The students were asked to interpret the boxes to discover what they could about the person who made the box. Gender issues emerged, and the class talked about those issues during an hour-long discussion.

Leader *Beth, tell us what you can discover about the person from looking at the box.*

Beth This person said that a lot of people think she's magnificent. There's words that say "think, smart, bright, books," and "sweet." And on the sides, it says, "Why can't you be smart like Renee? You should only hang around smart kids. You're a human dictionary, and you always get As and Bs. You're so smart. You must love school." And on the inside, there's a baby, Woodstock, and there's glitter. There's words that say, "weekends, summer." There are pictures of a troll, an ice skate, a crayon, and an eraser. I think on the outside, she's saying that everybody thinks she's so smart.

Let me interrupt you for a minute, please. How do you know the artist is a she?

Beth Because it says "Renee." [She knew which classmate made the box.]

Okay. You know who made the box, but to me Renee could be a boy or a girl. Would you know it was a she if the artist didn't have her name on it?

Beth No.

Good. Why wouldn't you know?

Beth Because a lot of people have trolls and ice skates and are smart. A lot of people like Snoopy.

Good. [Beth gave good logical answers, and knew that boys and girls could like the same things. Later, Karen's comments about the box she was discussing raised similar issues.]

Karen On the outside, I think this person likes origami, and he likes animals, especially underwater ones. He's a bright person because of the colors he uses on the box.

You said "he." Is that because you know so or because the box looks like it was made by a he?

Karen I think it looks like a he.

3.4 Kari Sinclair, grade 3, Inside-Outside Box: My Treasure Chest Is My Heart.

What makes the box look masculine?

Karen Because blue is a boy color.

[Karen used *he* not because she knew the box was made by a boy, but because it looked as though it was made by a boy. Her reason was that blue was a boy color. At this point, instead of letting Karen continue her interpretation, the class could have been led to consider that boys don't own the color blue, and gone on to discuss associations of gender with colors. This could have led to how societies construct meaning, how those meanings are culturally specific, and that they are invented, not natural. However, just alerting the class to be aware of how they were using *he* and *she* was critical. Later, Meagan qualified her identification of the maker of a box with "probably," and Debbie began saying "he or she."]

Meagan This person on the outside likes music, and he likes sports, whoever it is, and they either like to write or draw because there's a pencil. It says on the outside, "I love to listen to music. I'm very good at basketball, drawing, and last but not least, soccer." The colors are very bright except for the background, which is black. On the inside, there's a picture of a heart, and I think the person is caring. There's a plane and a sports car. They probably like those.

Okay. So what do you know about this person?

Meagan Well, that it's probably a boy. The outside is different from the inside because on the outside, it doesn't show that he's caring or anything, and on the inside there's a heart.

What do you think he's trying to express with the heart?

Meagan That he's caring inside.

Caring about what?

Meagan The earth. [There is a pasted picture of a globe in the box.]

Debbie I think he or she might be a really caring person; they really like to help people; and they have a big heart.

Good. Any other thoughts, ideas, questions?

Debbie I think on the outside, he's kind of boyish; but on the inside, he's kind of a little bit girlish, really caring, with the hearts and everything. On the outside, he like sports, and he wants us to think he's tough; but on the inside, he's not really like that.

I'm guessing that you're troubled by the word girlish. So why don't we change the word. What if I said that everyone has masculine sides and feminine sides, or strong sides and soft sides? That we have opposite sides in each of us? Some psychologists say that we all have a masculine side and a feminine side. Some people show one side; some people show another side. [Pause.] Do girls ever show a masculine side?

Kati Yes!

Samantha Yes, when I'm doing sports. Girls play sports.

Do you think it's good when girls show their masculine side?

Samantha Yes!

Why is it good?

Samantha Because they're showing people that they're really good at sports and other things.

Jason I think it's good because it shows that a woman can be as powerful as a man.

Renee I think they're really expressing themselves when they show both sides of themselves.

[There was consensus that boys and girls could do

similar things, that it was all right for girls to play sports and be good at sports. Jason had offered the girls support. No one, however, was giving permission to boys to do what are considered girl things.]

Let me ask this question. Is it harder for boys to show their feminine side than for girls to show their masculine side?

Paula I think it is harder for boys to show their feminine side because I really haven't seen a boy act feminine; and girls, a lot of my friends and I, are not embarrassed to act masculine.

Jason I think it would probably be harder for boys to show their feminine side because they have to have a tough reputation.

Sheila I think it's harder for boys to show their feminine side because they get teased, because they think they're all cool and everything. But with girls, it's easier because it's something that they do everyday.

What would some examples be if boys were to show their softer side, what we're calling their feminine side? Can you give me some examples?

Christine Like hugging someone.

Sheila I think if boys played dolls.

Do you think boys would like to be able to play with dolls if they weren't made fun of?

Christine I think maybe, yeah, a little bit, because it's fun.

Reflection

In this interaction about gender, there were risks: I didn't want the discussion to degenerate into silliness; we were talking about an individual's sculpture, and because the individual was revealing in making and showing the box, I did not want to embarrass him or her or anyone else in the group. Gender issues can be sensitive ones, especially for students about to become adolescents.

Try This

Have a student in an art-history class interview one of your most prolific art students about his or her work. The art-history student conducts a "studio interview" with the student artist, and then uses examples of the artist's work to present to the class an overview of the artist's career, who and what have influenced the artist, and what direction the artist might take in the future.

The girls expressed confident acceptance of having a masculine side and said that it was likely more difficult for boys to be soft, because they were expected to be tough. I asked the class for examples of what some things boys might want to do if they were freer to act like girls, both to extend the conversation to get some specific examples of vague generalizations. When Renee and Christine offered that boys might like to play dolls, none of the boys jumped in to agree with the girls. I was curious as to whether the boys would like to play dolls, but I did not want to ask them directly and embarrass them. We had pursued these issues for one session, and as an art teacher, I felt a responsibility to keep the class on the track of an art lesson, interpreting their work and showing them that we all hold learned assumptions about what colors and objects are masculine and feminine, that these assumptions are learned and socially conditioned, and that we can question them and think about them. The teacher who has a class for the whole year can watch for other gender issues that might come up during projects, and can pursue the issue further.

3.5 Lorraine Tapia, high school, Untitled, 1996. Mixed media, H: 3'
(91.4 cm).

Artistic Influences and Historical References

Discovering and discussing influences and references in student artwork, whether these allusions were intended or not, helps students make interpretive connections, and can provide a bridge between studio and art-history courses.

Three Critiques about Influences

High-school students from different grades and different art courses participated in these critiques. The students are in an art program designed by Ms. Thayer[6] and her colleagues that bridges art history courses with studio courses.[7] Students attend school in a racially diverse arts-oriented school, in Phoenix. They each selected one to three pieces—including sculptures, drawings, paintings, prints, and photographs—to bring to the critique.

Critique 1

The first piece discussed was a three-foot-high sculpture that Lorraine had made of plaster and steel wire. It was an odd-looking piece with a torso, head, and long, leglike steel wires coming from the torso and extending to three small wheels at the base.

Nathan It looks something like a person riding a tricycle, but it has long legs like a horse's, with wheels at the end. It reminds me of Salvador Dali.

Leader *How is this like Dali's work?*

Nathan Dali used horses in his work. Or elephants with four joints, like four knees.

Good. I'm going to follow up on influences because I know that you are studying art history as well as art-making, and not all high-school students study both simultaneously. Does anyone see other influences besides Dali's?

Martin A tricycle.

Good. That's a reference to everyday life. [This was to help students see that there are distinctions between references to art and references to the world apart from art.]

Santiago It may have something to do with youth, because of the tricycle.

Sandi Well, it's tilting, and youth are awkward, so it might also have to do with that. The front is sort of jagged.

Mario The way it's broken could be, like, its will, and they tried to bend the will of the youth.

It has a will to live?

David Yes. They could have tried to break the will. But the broken one is still standing. It is still strong.

Great. Any other ideas about this sculpture?

Damon It looks like it's supposed to be old. It reminds me of a caveman.

Ressa It looks prehistoric. It kind of looks like rocks instead of plaster.

Laurel And the wheels look like they were carved out of stone.

Martin It looks Cro-Magnon.

Mario Just for reference, do you remember those faces that are on the side of a hill? Huge faces, on Easter Island?

Martin Yeah, it looks like Easter Island.

Easter Island is another reference. Very good. We now have references to Salvador Dali, tricycles, and prehistoric art.

Santiago Well, it looks old, but the way the wheels are braced, it looks kind of futuristic, more modern.

Good point. So, this figure looks like an Easter Island prehistoric figure, but this lower part of it uses mod-

Bring to an art-history class a project completed by students in a studio class. Rather than asking for general comments, ask the students to examine the artworks as historians might. Ask them to look for and identify influences of culture on the artist, and to explain any icons and references. What people, objects, and places can the students identify? See if they can find information that is harder to detect. Ask: For whom was the art made? Where is it meant to be displayed? What do you think is the age of the artist? Why? Are there indications of the artist's social or cultural background? Gender? Religious beliefs? World views?

For example, third and fourth graders used "pogs" from "The Lion King" on their inside-outside boxes. Ask the art history students to examine and explain what icons and references such as these mean in the society which produces them. How is the artist using them? Art historians studying seventeenth-century Dutch still lifes, for instance, must discover what lemon peels signified to the people for whom the paintings were made. The art history students should also look for information that is harder to detect.

ern technology—it's steel, it has wheels. They didn't have wheels in really ancient days. That's a good point. I'm impressed with what you are all saying. [At this point, we went to another piece.]

Critique 2

Gabriel's piece was about four feet tall, made of natural materials such as long thin sticks, twine, rawhide, and folded paper. The sticks were bound together to form a free-standing structure from which hung, by a thin piece of twine, a hollow form made of paper.

Nathan The piece looks like it's from a southwestern Native American group.

Ressa I see Asian influences.

[I asked both Nathan and Ressa for reasons for their associations. Some associations might be very idiosyncratic, making sense only to a particular viewer.]

Nathan The whole structure is like a tepee. The elements hanging from the paper structure look like feathers, even though they're not actually feathers. The stuff binding the sticks together looks natural, like it's hide or rawhide, and there's bark around the joints. This paper thing that's hanging from the string is probably really paper or cardboard, but it looks like leather. [The class understood that he was implying that many Native Americans use feathers and leather in their artifacts.]

Ressa The paper structure hanging in the middle reminds me of an Asian vessel for prayer, and of Japanese origami objects. The way that the paper part is set up, hanging, it made me think of things that are hung in their houses.

Laurel I think that it uses natural elements, and it sways softly in the wind, and I agree it looks sort of

Eastern, like from China.

Santiago Or someplace where they would go to quiet down, to get away from everything. The thing looks like it is above ground level.

Laurel It's free. It's not busy. It's still calm. Even though it's free, it is still confined, because it is part of the structure.

Ressa There's detachment there. It's hanging from a very thin string. It might fall. There's apprehension there.

Joe It looks like there could be something in the inside of the paper structure, and it makes you wonder what's inside it, and why it is so light.

What might it contain?

Ressa I think it contains something spiritual, like peace, or a soul. It seems like people are trying to go up and get into it.

What about it makes you feel that way, Ressa?

Ressa Well, it's meditative. And if you're meditating, you want to get to a different state. And then, so, the person wants to climb up the structure and reach the state that's inside.

Santiago It's almost like your own soul, and you're trying to find yourself, and it's difficult.

[The discussion ended here. The students had come up with good ideas, and their interpretations seemed to fit the piece. We all gained knowledgeable appreciation for the sculpture that we had discussed.]

Critique 3

The class pursued historical influences they could identify in various works. About one work, they mentioned Greek and Roman sculpture, Michelangelo's *David* and *Pietà*; in another work, they saw a likeness to Jackson Pollock's paintings. The class then talked

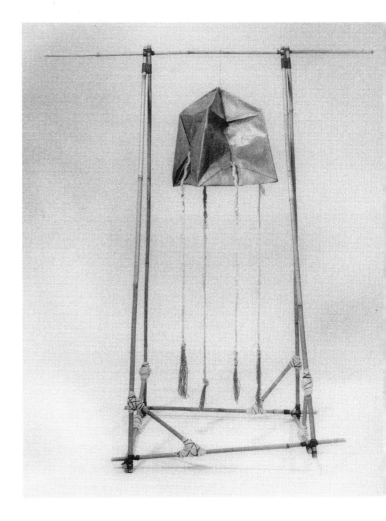

3.6 *Gabriel Cypher, high school,* Untitled, *1996. Mixed media, H: 4' (122 cm).*

Ask a student or a team of students to curate a show of student work. Explain that a curator is a person who usually works for an art museum, and decides what to show, why to show it, and how.

Ask the following questions for the curators to consider:

- Will you show the work of one student or many?

- If you show the work of one student, what pieces will you select and why?

- Will you display them chronologically or by some other organizing principle?

- If you hang a group show, which artists will be included and why?

- Will you hang the work according to themes of subject matter, similarity of media, or some other organizing principle?

- How many works by each artist will you include?

- Will you hang all of one artist's work together, or disperse them among other artists' work?

- What wall labels will you prepare?

about a picture that Maggie had made, a profile of a female figure from waist up, made with brush and ink on a piece of foam core, about 16 x 24". The figure's face turns upward, with open mouth, and she is set against a black background. A bright yellow circle seems to glow within her head, and a bright reddish circle glows in her bosom. A feather or leaf floats opposite the face in the black background.

Leader *What do you see here?*

Lorraine I see an inner self, like back to the meditation idea. They say that you have chakras, like in your mind and by your heart, and those could be the real bright colors in the woman.

Okay, chakras. Where does that idea come from?

Lorraine I don't know for sure, but I think it's a Chinese idea.

Joe Chi. You have an inner self like a soul that you project.

Gabriel Like an aura.

David Your id.

We've begun mixing East and West here. I think chakras and chi are Eastern concepts, probably from India, although I am not positive, and we would have to research these ideas. Then you are also suggesting id—as in Sigmund Freud's id, ego, and superego—a Western notion. [Further into the discussion, Maggie spoke about her work.]

Maggie You've missed the trees in the picture. These are important because we could become one with nature if we were in nature, and were quiet and would meditate. [Maggie is a Native American, a Yaqui, and she brought a new perspective to the discussion. The class had three sources of interpretive insight with which to deal in interpreting her piece: Eastern influences of chakras and chi, Western

European Freudian psychology, and a Native Southwest American notion of being one with nature. The class could have researched each of these perspectives; then they would have become better grounded in relevant theory from different cultures, and could have further interpreted the painting and deepened their understanding of it.]

Media and Aesthetics

The high-school students of the previous critiques had also brought in portraits done in different media: the questions related to the nature of art, special attributes and properties of groups of art, and other large topics. Generally, the students were not asked critical questions, which usually pertain more specifically to an artwork or group of works (What do you see in this painting? What do you think the painting expresses? Why is it a good painting?).

A Critique about Philosophical Issues
The students compared the medium of photography with the media of drawing and painting. The class first discussed what the photographs expressed, and then answered some philosophical questions.

Leader *How can a camera, which is a machine, be expressive? How can a person with a machine be expressive?*

Derrick By the way you can freeze everything.

Lorraine The camera itself isn't expressive, but what it captures is.

Nathan You know, with the camera, you see something you want to capture; you don't have to paint it; you don't have to sculpt it real quick; you can just take a picture and freeze it in time forever. You can get exactly what you want to express in a photo-

graph. You can keep taking picture after picture until you get what you want.

Okay, Nathan, but what do you mean by saying you can get exactly what you want with a camera?

Nathan (referring to a photograph of two boys) Well, let's say that these two kids were sad first, but the photographer was trying to get the kid to look proud of his brother, and the other kid to smile. He could say, "You make your face sad, and you make your face happy," and he could tell them to look the way he wanted them to look.

Ressa You can manipulate.

Nathan I think the camera person is the artist trying to create art through pictures. The people are not really the art themselves. The pictures, the finished picture, is the art.

Lorraine You are asking how a camera can be expressive, and I think that it's not necessarily the camera that is expressive, but what it captures.

Okay. It's what it captures. And what it captures is dependent on—?

Martin The person taking the pictures.

Yes, the photographer. So how are the photographers of these pictures being expressive? What choices did they make? What did they do to be expressive?

Lorraine Lighting, and also the composition, like where the subject is in the picture. Also color.

[Some of the photographs were originally black-and-white photographs that the photographers had then hand-tinted. The students eventually distinguished between photographic color (such as color in Kodak or Polaroid prints) and color that the photographer added with a brush and paints. They also distinguished between "natural" colors captured by fi]

and "transformed" colors made by artists.

The class returned to discussing whether Nathan's earlier philosophical claim—that a photographer can get exactly what he or she wants with a camera and film—was true.

I then pointed to a representational painting that was not realistic, that was quite distorted and emotional] *Can you do a picture like this with photography?*

Damon I think you can make the same feeling, but you can't, like, do the same thing.

Okay. Why and why not?

Damon Because when you take a photograph, then you can do a whole lot of things with the photograph; and when you make a painting, you can do a lot of things in a painting that are different.

What are the differences between photographs and paintings?

Donte Well, with painting, you can express more, of course, because with photography, you couldn't make these trees look like they are crawling up the woman's back, and they're miniaturized, and you can see the inside of the woman's soul. You couldn't do that with photography.

Good point. And why couldn't you?

Donte I'd say you can't so much really imitate some technique like brushstrokes. You can't really get that kind of stuff with photography, but you can set almost the same tone, the same feelings, with photography; you just can't use the same techniques or the same ways of doing it. Like with surrealism. You can't do surrealism with photography. You can't have things floating in the air, like castles and stuff. So that's the advantage of painting.

Lorraine But you can manipulate photography and combine two images.

Gabriel Yeah. You can collage items. So I guess you can express the same things, but it's a different approach.

Lorraine It's more of a challenge to express something through photography. With photography, you have to find something, or something has to be there that evokes emotion that you want to get across; but with painting, you can just get straight to the emotional.

I think what you said is very important. Want to say that again? Same words? Different words? [This was to reinforce her thoughts to the class.]

Lorraine With photography, you have to find something to express what you want to get across; but with painting, you can just go express it however you feel it. Whatever it looks like to you, you just paint it.

And why is it true that you have to go find something first to make a photograph?

Lorraine Because you need something to take a picture of.

Santiago Yes, unless you were going to make an object and then take a picture of it to set the mood or the feel that you want, you'd have to find something that portrays that to you.

Okay, good. I want to switch the question slightly. [Pause.] *How does a photographer think versus how a painter thinks? How do you think when you're painting or sculpting, and how do you think when you're photographing?*

Lorraine Well, when you're painting, you're translating an image that you see in real life; and when you're photographing something, you're going straight to real life and then manipulating that to your opinion of that subject.

Damon When you paint, it doesn't necessarily have to be real; you can make it up in your mind.

Donte In painting, you see it in your mind before you paint it. But with photography, it's there, and if you miss the shot, you miss the shot.

Reflection

These students were discussing issues that aestheticians, semioticians, and photography historians, critics, and other scholars of photography have explored and continue to explore. Nathan maintained that photography is a means of picturing that is not significantly different from other forms of picture making. He could find support for his arguments in the "photographic conventionalism" that theoretician Joel Snyder proposes.[8] The early, influential American photographer Edward Weston would have been proud of Damon and Donte's insistence that photography is different from painting. When Donte said, "you can't do surrealism with photography," however, Lorraine knew differently, and could have cited the surrealistic photographs of Jerry Uelsmann. Perhaps she knew of him and that he combines many negatives to make one photograph. Lorraine's point that the photographer first has "to find something" is the cornerstone of the definition of photography by French semiotician Roland Barthes.[9]

Knowing some photography theory was critical to conducting this discussion about the aesthetics of photography. Such knowledge allowed me to pursue certain lines of questioning as more relevant and important than others. However, the students were allowed to discover what they tacitly knew or were learning during the discussion. Had I had more time with them, I would have reinforced their answers by showing them surrealistic photographs, for example, or explaining Roland Barthes's thinking to reinforce and further what Lorraine had said.

Thinking About Media

Artists who work in one medium think differently when they then work in another medium. A photographer, for instance, always has something in the viewfinder and thinks about what to include and exclude as the camera moves up, down, in, or out. The painter, however, starts with a blank canvas and adds to it. Photography, in this sense, is a subtractive medium. Painting is an additive medium. Ask your students to discuss how they think when they are using different media.

- What are the advantages and disadvantages of any particular medium?

- What are the limitations of any particular medium?

- What does any one medium allow an artist to do best?

- Are there "wrong" or improper uses of media?

- Teachers in the Bauhaus workshops wanted a medium to look like the medium it was. For example, they believed poured concrete for a building's wall should look like poured concrete. They would leave it textured from its wooden forms, and gray instead of painted. They considered cardboard to be beautiful, and would use it, undisguised, to make furniture and other items. Do you agree with these "honesty of materials" principles? Why or why not?

Meaning in Simple Objects

Even the simplest of art projects can be useful for a group discussion; the objects produced have potential for generating interpretive thought.

Two Critiques of Ceramic Objects

High-school students in a beginning ceramics class had produced a variety of ceramic objects, such as vases; drinking mugs; sculpted, symbolic ceramic self-portraits shaped like automobiles, couches, snails, and other objects; and playable flutes, based on Peruvian clay instruments.[10] Students attend school in a primarily upper-middle-class community.

Critique 1

The students gathered their ceramic mugs in the middle of a table, and agreed that they would try to decipher meanings in the mugs. The mugs were six to eight inches high, built by slabs rolled over cylinders, with pulled handles. They had some surface decorations and one-color glazes. Although the mugs were unsophisticated and not particularly well crafted, they were typical of work in a beginning ceramics class.

Leader *Amy, since you were the first to mention meaning in relation to the mugs, can you get us started in the discussion?*

Amy Some of the mugs are taller; some are shorter. People varied in the way they designed the mugs, so it means something to them, how they can use them.

Okay, good. So we can see meaning in how they were designed to be used. Good.

Summer They're used to drink out of. They were made to be drinked out of, so they were made to look a certain way.

Good. How else do these mugs express meaning?

Natalie How they look. Weird. They have different shapes and forms and bumps, and they're lopsided, crooked.

Okay. How does the weirdness communicate or express?

Natalie It's right there! They stand out. People made them. They express the person who made it. By the size, that they drink a lot or drink a little. Bigger or smaller handles. They show that a person has big hands or small hands.

Great! These are good answers. Since you are beginning ceramists, how do I know that the person expressed something rather than just not knowing how to make it better?

Summer You have to design it and shape it. It shows how they have patience to fix it.

Good. They do show patience. They show that someone worked on them and designed them. How about a Styrofoam cup? What do these ceramic mugs express that a Styrofoam cup doesn't express? [This required the students to think differently; namely, to think comparatively.]

Natalie Styrofoam cups are all the same; they all look the same; they all have the same texture; and they're all the same color. But if you look at these mugs, they are all different in their own certain way. And, like, you can't hold certain stuff in a Styrofoam cup like you can hold in these, because these have handles on them.

Summer Paper and Styrofoam mugs are easy to collapse, and these aren't.

Natalie You can make these the way you want to, but Styrofoam cups are made for you.

Summer You can't wash Styrofoam cups like you can these. These are better for the environment.

Natalie These are creative. Styrofoam cups are not creative.

Are you sure? How are Styrofoam cups not creative? [Someone created Styrofoam cups, and those new cups, at the time, were likely considered creative.]

Summer They're boring. Like if you walked into a store, you could not see a cup exactly like the one you made.

Good. These are unique. One of a kind.

Natalie Styrofoam cups are made by machine, and these are made by hand.

Do you think Styrofoam cups are expressive? [I moved the discussion away from creativity and back to expression, the major topic. Creativity and expression are not synonymous.]

Brian Not really. They're just practical and can be easily mass-produced, so I don't think they express anything about the person who made them.

I think they do express something, but what they express is that they are practical, mass-produced, and the other things you all said. You are right, though, in that they don't express anything about the individual maker the way your mugs express things about you who made them. That's an important difference, and you've said it well. Are these cups more personally valuable than others that you might buy?

Lori Yes. These have sentimental value. You could not replace any of these if you broke one. No matter how hard you tried, it's never going to look exactly like this one.

If you broke your own, it would be sad for you because yours has sentimental value to you because you made it. What about if someone else's was broken? How would you feel?

Peter You'd feel bad because someone spent so much time on it. You'd think about the person and feel sad for them that theirs got broken.

Good. How else would you feel differently about one of these being broken, compared to a cup you bought from a department store being broken? [I wanted more discussion of this topic if I could get it.]

Michael You wouldn't mind so much about the department store cup being broken, because you could replace it. You can't replace these.

José Store cups are so perfect. These are so far from perfect.

A perfect cup is not as good as this cup, which is not perfect? [Pause.] *I think I agree, but it sounds strange to say that a perfect cup is not as good as an imperfect cup. Who can answer why an imperfect cup is better than a perfect cup?*

Michael These can't be duplicated.

Lisa Our mugs are more human because they're not perfect, and no one is perfect.

Reflection

This turned out to be a good discussion; the students were able to talk about meaning and the mugs they had made. They defended the aesthetic and sentimental value of the mugs, and seemed to be able to distinguish between sentimental value and aesthetic value, although I did not ask if they recognized a difference between sentimental and aesthetic value.

I did not want to push for interpretations beyond what the students offered—their mugs were expressive, and their mugs had personal value. I think this is enough of an interpretive discussion for mugs made by beginning students. Some artifacts present multiple avenues for interpretive discussion, and some don't. Different types of artworks require different interpretive questions and raise different

issues. As teachers, we should tentatively decide what we might expect students to interpret from different artworks. The questions we ask ought to fit both the artworks and the students' abilities.

Critique 2
This discussion of ceramic self-portraits that high-school students made was likely to generate more interpretive thought than the functional mugs had. Following interpretive discussions about a ceramic portrait of a girl as planet earth, and another of a boy as blades of grass, the class discussed a piece by Marick, a boy in the back of the room who seemed uninvolved. It turned out that he was more than uninvolved; he was actively resistant.

Leader *Marick, is this your piece? Is it a self-portrait?* [Marick refused to answer; he said that I had already told the class I didn't want the artists to speak about their work. A dispute about interpretation ensued. The conversation started with trying to interpret an artwork but moved quickly and quite naturally and sensibly to a philosophical discussion of meaning in art.] *Any ideas about this one by Marick? What does this express?*

Roy I don't know. Maybe he thinks he's in a shell.

Well, don't guess at what is in his mind, but look at the object and see what it expresses. [Students often begin interpretive discussions by taking guesses at what they think might have been in the artist's mind. This is a time to redirect the students to what they can actually see.]

Jim It's a snail.

It does look like one.

Kerry Open-mindedness.

Why do you say that?

Kerry Because it's open on one side.

Peter Emptiness.

Marick For there to be any expression, I mean, wouldn't the person have to put something in it? I mean, aren't they having to communicate an idea? Let's say I just made that, that I wasn't really trying to communicate anything. You can come up with something, but that's really not expression. For a thing to have expression, wouldn't the person who made it have to put some expression in it? Wouldn't they have to have an idea? Let's say I just made that without having any idea.

That's a good question. What do the rest of you think about that? [Drawing the class into the discussion avoided a confrontation with Marick.]

Ancia What?

Marick, ask your question again.

Marick Well, I just made this to turn in a project to get a mark in the grade book. I didn't mean it to mean anything, so it doesn't. You can't infer anything from this. It doesn't mean I am empty inside. It just means I wanted to get a grade. So, for there to be any expression, I would have to put it in there in the first place, and I didn't, so there isn't any expression.

Do you think he's got a good case, or not? [The students gave only yes or no answers; no one elaborated.] *My answer would be that one day Marick made this art object. I'm not sure what was in his mind when he made it, but now it's here. It's in the world. If we put it in that display case there in the window, I'm going to look for meaning in it. It might not be the meaning Marick had in his mind, but it's an art object in the world, and, therefore, I get to make meaning about it. That would be my answer.* [Marick was working from a different philosophical view of

meaning. He thought of meaning as something that was in an object, much as gold might be in the earth to be mined. Meaning in artwork, however, is generally something that people construct. Viewers make meaning rather than find it. Since Marick did not put meaning into his artwork, he thought no meaning could be found there.]

Marick So the public gives the work of art meaning, not the artist?

I think it's a combination. If you hadn't made this at all, I wouldn't be thinking about it. But you did make it, so now I am thinking about it, and now I can wonder about it because it is interesting. It's spherical, enclosed, heavy, gray. It looks hard and impenetrable, and when I turn it around, I see that it is empty on the inside. Whether you meant it or not, whether you were playing around or being serious, you still made something, and the rest of us get to think about it. Other thoughts on that?

Tom What if you made something on the wheel, but it didn't turn out the way you wanted? You had an idea, but it didn't come out, so it actually has no meaning to it. You're saying that everything has to have a meaning to it; but, in a way, everything doesn't have to have meaning. Say I made something that didn't have meaning to me, but it got fired in the kiln and then it got broken. I wouldn't be depressed about it, because it didn't have meaning to me.

All right. Let's slow down. We have a confusion here, I think, about how we are using the word "meaning." First, we have meaning to you, the maker; and we have meaning to us, the viewers. Then we have meaning as sentiment—how you feel about it—and meaning as ideas that we generate when we look at what you made.

Terry Well, if I made something and I didn't have a meaning behind it, I wouldn't want other people to put some meaning to it.

But do you have a choice? Why not, Kerry?

Kerry Because everyone can have their own opinion. They can have their interpretation of what you've made, and they have a right to say it.

Once this gets put in the display window, people are going to look for meaning, I think. Because people are curious, they are going to look for meaning.

Marick Not at the high-school level. If you went to a museum, then it would be different; you'd see something, and you'd say, "Wow, there's something here, there's another level." But not here.

Marie You don't know that!

Martin That's not true, because when you listen to music, you always try to find the meaning of a song.

Marie Exactly! Like you listen to the words, and then you're actually feeling something, and then you're trying to hear what they are trying to say.

Natalie Someone didn't mean to do it by putting the words together, but there still is meaning in there. [Natalie rightly asserted that words may have meaning independent of what the person using them means by them.]

I think people look for meaning. I think I could come into this room, with none of you even here, and I could find meaningful things. What you have made, the way things are in the cabinets, the way things are displayed. I think the world is full of expression, full of signs, and I'm interested in them. And I don't think the objects have to be in a museum. I think this object that Marick made is interesting, even though it's not in a museum, and even though it is not made by a famous artist. I can tell it is made by a person,

and I want to know more about it. I think some of you are afraid that we are putting stuff into the artist's mind, which I am not really doing. I am not trying to read Marick's mind; I'm trying to read his sculpture. It has a certain form, color; it is closed and open—

Marick You're just listing characteristics; you're not giving a meaning.

I think you are right. I mostly described the characteristics, but I did make some implications. You have a good point. Let me take the implications further. I think there is symbolic content. The sculpture looks like a snail. A snail tends to be very private, very closed. You can't get at it. It has a protective mechanism. But this one is different because it is open in the back. So I think it has symbolic meaning. I don't know what was in your mind, but now that I have this object, I see something symbolic here, something hard and closed on the outside, but inside it's accessible. You can get inside. But what's inside? Well, maybe nothing is inside—

Marick Can I tell you the meaning of it? Because you're wrong!

Okay. What's the meaning of it?

Marick Well, it's not finished. You said it was empty inside, but it won't be empty when it is finished. I can't reveal what will be in it at this point in time.

As a person viewing this, I am at a disadvantage because I thought it was finished, and now you're telling me it is not.

Marick That's the point. The public can infer a lot of things, but they could be all wrong. You don't really know what state it's in—

Natalie He's implying from what he sees now; he's not implying that it's done; he's implying like it is now. He's not implying that maybe you should put

this in here, or that in here. He's just implying about how it is now—

Marick I'm just saying you should be careful. You should be careful about judging so quickly like that because you don't know all the details—

Natalie He judges how he sees it now; he's not going to ask you a bunch of questions about it. He views things, and he expresses how he feels about them and the meanings he gets from them—

Marick I'm saying the meanings could be wrong. That's all I'm saying.

Natalie His meanings are not wrong. Maybe they're wrong to you because he's not inside your head, but—

Marick But I'm saying there's a definite meaning to a piece of art, and the artist gives it that meaning—

Natalie No, you're wrong—

Wait a minute. Time out! Marick's got a good point, Natalie, and you've got a good point. Actually, philosophers talk about this. There's a philosopher, a literary critic named E. D. Hirsch,[11] who maintains Marick's point of view—that the artist has an intent; if you want to find out what this thing is about, you have to find out what the artist meant it to be about. According to Hirsch, it is either about it or it is not about it. You have either a right interpretation or a wrong interpretation. And that's what Marick's arguing, and he's defending it well. You and Marick have different points of view, Natalie, and you are also defending yours well. You are arguing that the meaning isn't dependent on what was in Marick's head, but that the meaning is dependent on what we see here in the artwork. We can build meaning without knowing what the artist thought. And this camp would say that's a cool thing to do, that you can't always go around asking artists, "What did you

Some days after this critique, Ms. Sivert had her students write descriptive, interpretive, and evaluative paragraphs about a ceramic self-portrait of their choosing. Lauren Grik wrote the following about a sculpture of a person in a cage:

"As I sit here, with a piece of art in front of me, and am told to analyze the work, confusion surrounds my mind. I take a minute to sort my thoughts. After I finished outlining my work, the feeling of its power and strength come over me. It made me realize how much is behind a piece of art besides the way it first appears.

This artwork is a cage with a small person inside. It is a grayish color allowing the person and the cage to blend together. The clay used to create this is stoneware. The stoneware is used to make the form of a hollowed-out, 3-D rectangular shape. The floor is solid, and the roof is opened with crisscrossed bars. Holding the bottom and floor together are columns or bars. Inside the hollowed figure is a rounded shape person to make the arrangement. The elements and principles are a very dull, grayish color. It is quite rough to the touch, and the feeling is very solemn.

This piece of art gives me the feeling of being confined, trapped. Not literally stuck in a cage, but emotionally. The feeling of not being able to express one's true thoughts or emotions. Another idea is the way society is created, forcing the person to be unable to be who they want. Society is taking away a person's goals or dreams, creating the person as what society wants, not what the individual should be.

The feeling the creator is trying to express grasps my attention. There is such strength behind its making. The idea of society trapping a person. Keeping one from being who they really are."

mean by that?" The artist might not be around; the artist might be dead; the artist might not want to communicate verbally; the artist might be very private; the artist might work subconsciously. We make meaning; we don't just go around and ask the artist for the meaning. So there are different philosophical views about this, and you can debate these things, and these things are interesting and important things to debate. Personally, I think we find meaning; we make meaning. I don't know Marick, but his object expresses stuff to me. I think I arrived at meaning whether he intended that meaning or not. I may not have gotten your meaning, Marick, but this is meaningful to me because I see symbolic content in it.*

Marick So the artist *doesn't* relay the correct meaning? Then is there any point in having the artwork out there? If I didn't even relay the meaning that I wanted?

Yes.

Reflection

Marick attempted to continue his argument after the bell rang as the rest of the class left. I did not want to discuss the issues further with him, so I told him that we disagreed with each other, that we were holding different positions, but that he had a good argument and that he was making sense.

This discussion was good and fairly sophisticated, especially for beginning art students who had not been introduced to conducting orderly art criticism in a group discussion, and who had not been taught aesthetics or means of building arguments about art. The tone of the discussion at times was hostile, but not destructive. I tried to focus the discussion on Marick's reasons. At times, perhaps Marick wanted to

win an argument rather than arrive at knowledge, but his questions and arguments were good and were worth pursuing.

I validated Marick's position with Hirsch's and also validated Natalie's and my opposing view. Validating responses with those of authorities whenever possible builds students' confidence in discussing art. Presenting authorities' views also lets students know that everything is not up for grabs and that there are answers to interpretive and philosophical questions. I wanted the students to see that positions can be argued and need to be defended with reasons. I did not want them to think that anything said about art is necessarily good, true, or reasonable. Our discussion was more than mere assertions, more than mere opinions; it had clarified some complex issues of meaning, interpretation, and art.

Conclusion

This chapter shows the richness of interpretive thought that can be evoked in students by asking them engaging questions about works of art that they have made. The inside-outside boxes generated discussions about different topics, even though the assigned project was the same. The students considered artistic intent, gender issues, and how media and materials are themselves expressive. Through interpretive processes, high-school students discovered references in their work, some that the artists intended and some that the artists were unaware of before the critique began. These students were also capable of debating philosophical issues about artistic intent and meaning, issues that critics and aestheticians themselves debate. Through discussions like these, students are better able to understand, appreciate, and enter art worlds beyond their classroom.

Interpretive critiques such as these are sufficient in themselves. They show that student artists create meaningful artworks, and that they can find meaning in and construct meaning about works that they and others make. When teachers ask good interpretive questions, students of any age can respond with thoughtful answers. These discussions are interpretive critiques—they are criticism—and the discussions could stop here. Criticism, however, can and often does include judgments.

Notes

1 Arthur Danto, *The Transfiguration of the Commonplace: A Philosophy of Art* (Cambridge, MA: Harvard University Press, 1981). Danto supports this notion.

2 Terry Barrett, *Criticizing Art: Understanding the Contemporary* (Mountain View, CA: Mayfield, 1994), 45–71; and "Principles for Interpreting Art," *The Journal of Art Education,* September 1994, 8–13. These sources present the author's other considerations of interpretation.

3 Dr. Jann Gallagher, independent artist and school administrator, Euclid City Schools, Euclid, Ohio.

4 Kitty Rose, grade 3 teacher, and Linda Duvall, grade 3 teacher; Roosevelt Elementary School; Terese D'Amico, grade 4 teacher, Thomas Jefferson Elementary School, Euclid, Ohio. Euclid is a large town outside of Cleveland with a racially diverse but predominantly white working-class population.

5 Michael Parsons, *How We Understand Art: A Cognitive Developmental Account of Aesthetic Experience* (Cambridge: Cambridge University Press, 1987) 86–98.

6 Roxanna May-Thayer, teacher of jewelry, fiber arts, and a freshman course on art and cultures, South Mountain High School, Phoenix, Arizona. This school attracts students interested in the visual and performing arts, communication arts, aerospace education, and law-related studies. The student population is about fifty-five percent Latino, twenty-five percent African-American, twenty percent Anglo, three percent Native American, and two percent Asian.

7 At the time of this critique, Ms. Thayer was working under the direction of Dr. Mary Erickson, Department of Art Education, Arizona State University, on a Master's thesis to merge art history into studio courses.

8 Joel Snyder, "Picturing Vision," in *The Language of Images*, ed. W.J.T. Mitchell (Chicago: University of Chicago Press, 1980).

9 Terry Barrett, *Criticizing Photographs*, 2d ed. (Mountain View, CA: Mayfield, 1996), 140–145. A more complete discussion of these positions about photography theory.

10 Peggy Sivert, art teacher, Mira Costa High School, Manhattan Beach, California. Manhattan Beach is a primarily white, upper-middle-class community.

11 E.D. Hirsch, *Validity in Interpretation* (New Haven: Yale University Press, 1980).

Chapter

4

Judging Student Art

During the interpretive critiques presented in the previous chapter, while we sought to decipher expression in and construct meaning about student artworks, we *implied* judgments of value, and in the case of the ceramic mugs, discussed value, although we *did not explicitly judge* this artwork to be excellent or that artwork to need change. Judgments were implicit: this "inside-outside box" confused viewers (and therefore maybe it should have been made differently); this sculpture conjures in viewers historical references to many different times and cultures (and therefore it is a fascinating and good work of art); and this mug reveals things about its maker (and therefore it is a good expressive as well as functional object). This chapter is about leading students in *explicit* critical judgments of artworks.

Art Critics

When professional critics judge artworks, they assert that the works are good (or not so good), and then explain why.[1] When judging, critics usually try to persuade people why and how artworks are good. They want others to appreciate art and find it meaningful.

Evaluative Questions

There are many ways to phrase evaluative questions. The question "Is this a good work of art?" invites both negative and positive evaluations—but more often it elicits negative responses because students usually associate critical judgments with negative judgments. Another question—How is this a good work of art?—directs viewers toward positive judgments. Comparative questions also elicit positive judgments: Which is the best work? Of all these works, each of which is a good work, which do you think is the best and why? If students do not think a work is good, the question "Why might others think this is a good work of art?" allows them to consider the possibility that it is good.

A discussion can begin with judgment. Some art educators assert that art should be judged only after describing it, analyzing its formal properties, and interpreting it. This can be counterintuitive and forced. Viewers often make immediate judgments. Then, however, if they are to be responsible, they articulate reasons for the judgments; while doing that, they figure out what the work is about. A critique can begin with these questions: Which is your favorite piece? Do you think it is the best piece? Why? What is the piece about? How would you convince someone else that this is a good work of art? This last question encourages students to think of judgments as persuasive arguments, and challenges them to provide reasons for their judgments.

Judgment Supported by Argument

Judgments are more than mere opinions: they are informed and carefully considered opinions backed by reasons and fashioned into a persuasive line of reasoning—an argument. Even if a critique begins with evaluative questions, students should eventually interpret the meaning of the work before they finish judging it. Students should not be encouraged to judge something without an understanding of what it is. Judgments can be used to lead to interpretations, or interpretations can be used to lead to judgments. However, judgments devoid of interpretations are not adequate.

Five Judgmental Critiques

These five critiques engage students in judging art and exemplify some principles of evaluative criticism.

From Interpretation to Judgment

This critique excerpt is partially interpretive and primarily judgmental.[2] Third graders at a school in Dublin, Ohio (a small, upper-income city outside Columbus) made three-dimensional wooden horses based on artist Deborah Butterfield's sculptures of horses. The sculptures discussed were those from another class that was given the same assignment. After looking at similarities and differences among sculpted horses (among theirs, and between theirs and Butterfield's), the class examined the selection of materials before judging the effectiveness of artists' formal choices.

Leader *How are these horses like Butterfield's?*

Stacey They're kinda abstract.

Molly They're different because they're made of wood. Hers are metal.

Do you think Deborah Butterfield used whatever she

could find, or did she go out looking for certain things?

Ita Anything.

Would she use Jell-O, for instance? [The class agreed that Jell-O would be too smushy and might turn rotten. They realized that "any material" was too broad.]

Sarah She used lotsa metal, and that's different from the wood we used.

How?

Jennifer The horses'd be stronger if they were metal.

Molly If you used metal, you could make it bend, but the wood we used would crack.

Christina Metal rusts. Her horses are rusty, but wood doesn't rust.

Does Butterfield like the rust? [I asked this question to get the students to think of rust as a choice rather than an accident.]

Adam Maybe she likes rust because it's the color of some horses.

Do you think that she used rusty metal rather than new metal because she could afford only old rusty metal? [The class agreed that metal was a choice.]
Which of these horses do you think Butterfield would like the best? [This variation of the compare-and-contrast question begins to elicit judgments, and also implies criteria for judgments based on interpretation: given that Butterfield's horse sculptures are good, and given that your horses are based on hers, what might she think of them? The question requires comprehension of Butterfield's work and requires the students to transfer to their own work what they know about Butterfield's.]

Stacey She'd like this one. [Brian's sculpture of a horse with visible ribs.]

4.1 Ayumi Kusawa, Untitled *(after Deborah Butterfield), 1995. Wood and glue, H: 22" (55.9 cm).*

For any assignment that is designed to teach students about the work of a particular artist or style, ask them how the artists would respond to the students' works. Which student works would the artists be most attracted to and why? Considering these questions will reinforce learning about the artists the students are studying and also will provide criteria with which the students can judge their own work.

Why?

Christina His is kinda realistic, but it's abstract like hers too.

Whitney She likes to show the horses' insides and their outsides. She'd show the ribs.

At this point, the class considered what materials they could have chosen from for their sculptures. This is an important consideration for any studio project. Artists choose materials, and their choice of materials is crucial to the art they make.[3]

Judging the Effectiveness of Formal Choices

The class was impressed with the sculpted horse Ayumi had made (see fig. 4.1). While discussing it, they judged the effectiveness of the brace that Ayumi had built to allow the horse to stand.

Brian The supporting thing doesn't look good [because it detracted from the realism of the sculpture].

Jason It's a good horse, but it looks like it has five legs.

4.2 Deborah Butterfield, Billings, 1996. Found steel, 7 1/4' x 8 1/2' x 32" (2.2 m x 2.6 m x 81 cm).

If Ayumi could have done it better, what do you think she would have liked to have done?

Christian She would've used fatter legs 'cause these are too skinny.

Do you think it's good to have the support, or would it be better if it didn't need the support? [I rephrased the question to direct attention specifically to the supporting brace. After some discussion, the students agreed with the evaluation that the sculpture would be better if it could stand without the support. The class then judged the effectiveness of the riblike pieces Brian chose to use in his sculpted horse (see fig. 4.3).]

Stacey The ribs make it look like a cave painting.

Zack They make it look like it's starving, or that it's dead.

Christina It looks like something hunted it and ate its skin off.

[The ribs might have been an effective echoing of how Butterfield reveals anatomical segments, but the third graders saw only an emaciated horse. The class interpreted whether they thought Brian was showing a dying horse. Some thought so; some didn't. Some thought his use of the riblike sticks was an attempt at abstraction.]

Is there anything realistic about the sticks [hoping that they would see a reference to a rib cage]?

Stacey The horse looks sick.

Does the rest of the horse look unhealthy?

Stacey No. Its tail looks good and not sick.

Jason The rest of it looks strong. [Even with this acknowledgment, they still saw the rib cage as indicating malnutrition.]

If Brian still wanted to keep the sticks for the horse's ribs, what could he have done to show that the horse was not starving?

4.3 *Brian H. Luce, Untitled (after Deborah Butterfield), 1995. Wood and glue, H: 13" (33 cm).*

Stacey He could've glued thin cloth over the ribs so that it wouldn't look so starved.

Reflection
During this evaluative discussion of the effectiveness of choices Ayumi and Brian had made, neither artist was present. The class had to judge for themselves the effectiveness of the artists' choices. Had the artists been there, they would have learned about the consequences of their choices, but they may have restricted the discussion by being defensive or too ready to agree with a judgment. The third graders realized that formal choices that artists make affect how people interpret their artworks. By judging the effectiveness of specific choices in a piece, the students avoided a summary judgment of the whole piece. They agreed that Ayumi's sculpture was impressive but that the choice of the brace should be reconsidered. Similarly, no one said that Brian's horse was not a good sculpture, but they saw that the rib-like sticks caused conflicting interpretations. The students made decisions about artworks, both interpretive (this sculpture is similar to Butterfield's) and evaluative (this sculpture would be better if it didn't have a brace), and learned to provide reasons for their decisions.

4.4 Ben Rader, grade 5, Untitled (after Matisse), 1995. Construction paper collage, 18 x 12" (45.7 x 30.5 cm).

Beginning with Judgment

This critique begins with questions of judgment.[4] These fifth-grade students live in a rural, mostly white and working-class community. Their construction-paper collages, in the manner of Matisse, were displayed in the corridor and accompanied by this wall label:

> **Matisse Cutouts by Fifth Graders**
>
> Students studied the life and work of French artist Henri Matisse, focusing in particular on the cut-paper collages he made during the latter part of his career.
>
> Students discussed Matisse's use of overlapping, repetition, and patterning; how he balanced and unified his arrangements; and the types of shapes and spaces he used (natural versus hard-edged) in his compositions.
>
> Students selected paper colors and constructed collages, and worked in Matisse's style.

Leader *The bank of Sunbury has decided to purchase one of your collages for the lobby of its bank on Main Street. You are to decide which one is the best one to represent the class, and to convince the board of directors with your reasons.* [This fictional scenario implies that all the collages are good and that the bank values the students' work and wants to buy a collage. The students wrote their reasons on index cards and read their reasons to the class.]

Brandy wrote *The bank should buy this collage because it's creative, it's high in contrast, it's colorful, it looks mysterious, it looks 3-D, and it overlaps. It's interesting the way she cut out her shapes and arranged them; it's arranged creatively. It repeats patterns of shapes. It has craftsmanship.* [Brandy

articulated good reasons, especially that the work is creative, looks mysterious, and has good craftsmanship. The overlap, high contrast, and color don't constitute reasons for a judgment. Something could be inappropriately colorful, or overlap ineffectively. Anna, however, stated that the collage was creative and mysterious, and implied that this was true because of the artist's use of color, overlap, and high contrast. She based her opinions on values (mystery, craftsmanship), not merely on what she liked.]

Ashley wrote *It* [the collage she had chosen] *has a lot of eye-catching colors and shapes. It looks like you're going into a three-dimensional world because it overlaps different colors, so it looks like you could just stick your hand into it and pick up a shape. It uses more than one or two colors, and overlaps different colors instead of putting blue on blue, or pink on pink. The shapes it uses are not boring, ordinary shapes like a circle or a square. The shapes are shapes that don't have a name; they just are cut like squiggle lines or jig-jagged.*

Aaron wrote *I'd choose this one because it's cheery; it has neat patterns; it will make people happy; it has nice color variations; it might bring out laughter.*

Toby wrote [directing his comments directly to the board members] *I think it would fit your purpose because it's original. And I also think it would fit your interior. We also recommend it because it has been commented on while it was on display in the school. Many of the people who commented on it are local citizens that use the bank regularly. It also has flashy colors.* [Aaron and Toby mentioned formal reasons and craftsmanship, but also considered who would view the piece and how the piece might affect the viewers who were using the bank, even citing their likely emotional responses.]

Reflection

Some students offered true statements about the collages, but the statements were not reasons to value the collages; what they offered would not count in persuading someone about the worth of a collage. One student confused descriptive facts with judgments of value: it has high contrast, it is bright, the designs look spontaneous. This student could have made this into a persuasive reason that the collage is good, by stating, "The design has high contrast, bright colors, and a spontaneous design; and these features would make the collage very interesting for the bank customers waiting in line."

Critical Judgments and Philosophical Judgments

In a different class of fifth graders, but with the same Matisse-like collages, the students entered into a discussion of aesthetics—they philosophized about the value of art.

Leader *These are two collages that the other fifth grade class has chosen to be displayed in the Sunbury bank. We want to convince the bank to buy them. We'll ask for $100 plus the cost of framing them. Give me reasons that we should give to the bankers.* [Some of the students' reasons were philosophical rather than critical: they spoke philosophically about the value of the art in general (aesthetics), or they defended the value of a particular artwork (criticism).]

Alan It will represent the children in Sunbury. It's attractive, and it might catch the eye.

Yes, I can see that they might be attractive, but so what if they are made by children in Sunbury? Why should I spend my money on children's art?

Samantha Because if you had art from another town, that wouldn't be good 'cause it's the Sunbury bank.

Okay. Why shouldn't I pick an adult artist from Sunbury? Why should I pick the art of a fifth grader?

Erin Because a lot of adult art is already hung up, and sometimes you get tired of it and you might want something by children.

Natalie Because kids' art never gets hung up outside of school.

All right, you want me to hang children's art because it usually isn't shown outside of school. But I want good art in my bank. How do I know this is good art?

Erin They took time to make.

Alan They're original.

Samantha They mean something to the artist who made them.

Okay! These are good reasons for valuing these works of art. Think about this new question. What are the people going to be able to see and appreciate in these collages?

Jon They can learn about the next generation.

Yes, that's a good reason. That's a political reason. Can you give me an artistic reason? Why are these artistically good? [Telling Jon that his reason was political rather than artistic was perhaps a mistake. Jon's saying that the value of a fifth grader's art is that it informs about the next generation is an excellent and insightful reason—and certainly an artistic one. Jon had done some good aesthetic philosophizing.]

Alan They're attractive. They're colorful.

Kate They're different from other artworks. They're abstract.

Why is that difference good? I'm afraid that people who come to the bank will want to see realistic pic-

tures of cats and dogs and horses. Why should they appreciate anything abstract?

Howard Cats and dogs are boring!

Randy These are creative.

Maggie If you want to see cats and dogs and horses, you can drive by a farm.

Madeline The page is filled, and you can look at the picture and actually see things.

Randy They're done carefully.

Eric It's bold.

Those are good reasons. Let's go to a money question. Why is this thing worth money? It didn't cost you much to make it. It's just construction paper and some tempera paint and some paste. That's not expensive.

Natalie Maybe they will be worth more when they get older?

Why?

Natalie Because the artist might become famous when the artist is older.

Okay, so I should risk my money on the collage because it might become valuable. I think that's a long shot for an investment, but it's possible. Why should a bank buy art rather than flowers, or why shouldn't I spend my money on mints and give everyone who comes to the bank a free mint?

Jon Flowers die and mints don't last.

Two themes unified this discussion: justifications that some of the collages were artistically good, and justifications of the value of art (specifically children's art) in society. Giving reasons why an artwork is good is a central art-criticism activity. Determining if and how art is valuable to society is a vital question of aesthetics, which calls for philosophical thinking. The

4.5 Sarah K. Corbin, grade 5, Plant, *1995. Pencil, watercolor, black marker, 12 x 18" (30.5 x 45.7 cm).*

To judge and grade art, ask: Of the art-
works here, in which ones can you best
see the artists' involvement? Which art-
works have evidence of the artists'
being immersed in their work (having
fun making art, getting pleasantly lost
in what they are doing, struggling to
get the effects that they want)? Can you
see evidence of the artist's involvement
and commitment to the project?

discussion merged criticism and aesthetics. Alan
offered a critical reason for valuing the collages
(they are colorful and attractive). Jon's reason was a
philosophical justification for the value of all chil-
dren's art (it allows a glimpse of a future genera-
tion). Jon wasn't justifying the value of one collage,
but all children's art. His second reason ("flowers die
and mints don't last") is also a philosophical justifica-
tion for the value of art over other items. Maggie's
point (if people want to see cats, dogs, and horses,
they can drive by a farm) was a philosophical justifi-
cation of a criterion of art—that realism may not
offer what abstraction can.

Judgment Based on Artist's Involvement

For a studio project, the art teacher set up potted
plants on tables around which students sat.[5] The stu-
dents drew the plants from observation with pencil,
mixed watercolors, and painted the drawings realisti-
cally. Then they reworked the drawings with black
marker. In a brief excerpt of the critique, the class
judged the drawings on the basis of the artists'
involvement. This general criterion can be applied to
any artwork, and can be a basis for assessment.

Will The drawings show how the artists feel.

Brent Some of them took time; some just are differ-
ent than others.

Leader *What kinds of attitudes do these pictures
show? Does the artist like plants or not like plants?*

Jamie Some of them look like they didn't like to
draw plants. Some look like they really didn't care.

*Jamie, you have a good point. Jamie's saying that—
in some of the drawings—he can tell whether the
artist cared about the plants. Which drawings
convince any of you that the artist really loved
the plant?*

Cynthia That one. It has shadow.

It does. But does that convince you that the artist likes this plant?

Cynthia It's got lots of color. It has a lot of craftsmanship.

What is craftsmanship in these?

Jenny If they look realistic.

Okay. By looking at these drawings, can you tell who enjoyed doing the project, who enjoyed the plants?

Jenny That one. It looks like a real plant. It looks colorful. She's putting all the things that were on the plant into the drawing.

Jamie That one looks like she's not involved. She didn't put that much detail into it. She didn't put many leaves on it, and it doesn't look like she cared that much about it.

Does anyone want to defend this one? Does anyone want to argue that she does care about the plant, but that her plant drawing is just different? [No one wanted to defend the drawing; the class thought that the artist hadn't invested sufficient energy in the project.]

Reflection

Involvement can be a motivational criterion that rewards interest, enthusiasm, and sincerity—and does not penalize those who are less adept in artistic skills. Teachers fairly easily observe involvement in some students—and its lack in others. Finding involvement in artwork may be more difficult, but these fifth graders identified amount of detail and care (and their absence).

By asking the class to defend the last drawing, I wanted them to know that a different style, or a different look, might be confused with lack of involvement, and that a viewer would have to argue on the basis of evidence in the work that it did or did no show involvement. Not only students have to defend their position; art teachers should be able to give students reasons in support of judgments and grades.

Seeking Approval and Advice in Critiques

This book began with considerations of a critique with adults and comes to a close with one. Three adults asked me separately for critiques of their photographs, and then agreed to have a group discussion over lunch.[6] Marlin has a degree in design; Mary has no formal art training; Barbara learned photography as an adult from a friend. Three others, who did not bring art, joined the critiques.

The artists first wrote what they wanted viewers to see in their work; then during the critique, they recorded what they heard the viewers say about their work. The artists listened and did not talk when their work was being discussed. The critiques were interpretive and positive; they only turned to judgment in a few instances. We took turns talking about each artist's work. I took turns with the others, trying not to dominate the discussion. I resisted answering some questions directed to me. Before the session ended, though, Mary asked for my personal view of her art-making, seeming to seek both my appraisal and approval. I reiterated my interpretive comments, hoping that she would infer that her work was good—good enough to generate and sustain concentrated viewing and discussion, the purpose of most art.

During the second critique, three more plus the original group were present. The same artists showed different work. Barbara brought fifteen photographs of different subjects: a rodeo, playgrounds, children, and landscapes. Marlin brought a self-portrait that she made for the critique, drawn in colored pencils. Mary brought a landscape done in

pastels. Marlin and Barbara wanted a judgmental critique focused on how they could improve their art-making. They wanted direct appraisals and advice from me, so I asked them to pose questions to the group, and then listen to the answers.

Barbara asked me how good a photographer she was and if she could make a living as a photographer. I said that probably most people could make a living from photography, or another art form, if they dedicated sufficient time and energy to achieving that goal. If she were serious about photography, she would have to scout the market to see how her rodeo photographs, for example, measured up to other rodeo photographs, and then make improvements in her work if it were not competitive.

The group asked about her motivations for making art: Was she really interested in photography as a career? Wasn't she happy just making photographs on the side? What did it matter how good they were if she were happy making them?

Each person picked one of Barbara's photographs and told Barbara why he or she thought it was the best one. We told her many good things about her work. When asked what she had learned, she commented on how she could improve one of the images. When I pointed out that she recalled something negative rather the many positive things we said, she indicated why traditional critiques often aren't effective: "Yes, I have the tendency to focus on the negative things I hear about my work."

Marlin wanted to know how she could make her self-portrait better, saying that she liked negative critiques because she learned from them how to improve her art-making. We took turns talking about her drawing. Despite her wishes for advice, all the comments were complimentary, and many were interpretive. We considered how she made the portrait, whether it was a self-portrait, and what we

thought the portrait expressed. We discussed her artistic choices and what we thought was her successful use of unrealistic colors. By the end of our comments, however, she remained dissatisfied, saying that we were "too nice."

Reflection

Mary, Barbara, and Marlin raised provocative issues about critiques. Should group critiques provide negative criticism to artists, even if that criticism is constructive and is said in kind ways? Should the art teacher's voice be the most authoritative in group critiques? Should critiques be used to give students advice on how to improve their artworks? Should this be the main purpose of critiques?

Although it runs counter to those who learned how to conduct critiques from college studio professors, for example, the answer to these questions is no. However, this book is for teachers of elementary-, middle-, and high-school students, and does not advocate giving advice to artists during group critiques. Further, the book suggests de-emphasizing the teacher's opinions and favors placing primary responsibility on the students to interpret and judge art. The teacher's responsibility in group critiques becomes one of facilitating learning by thoughtfully directing students in interpretive and evaluative discussions. There are reasons for these emphases.

Instruction in art-making takes many forms and is not limited to group critiques at the end of a studio project. Good teachers certainly help students learn to make art well, and they do this in several ways, often by attending to students individually while they work. There are times when it may be appropriate for teachers to tell students when they are not doing well, and how they might make an artwork better. This may best be done one-on-one.

Conclusion

The critiques presented in this book are meant for teachers to help students, individually and as a community of learners, to discover interpretive and evaluative information about their artworks. In this way, they can continue to look at art that they and others make, and intelligently consider it, independently of the artists and of teachers. The critiques are meant to have students value the art that they and their classmates make—not because the teacher says that it is good, but because they can hear from their peers and can see for themselves that it is good. If we teach children to independently enjoy and value art, we will have taught them valuable lessons for life.

Notes

1 Terry Barrett, *Criticizing Art: Understanding the Contemporary* (Mountain View, CA: Mayfield, 1994) 80–108. More about professional critics judging art.

2 Sharon Daugherty, art teacher, Thomas Elementary School, Dublin, Ohio. Dublin is a small, upper-income city outside of Columbus. The majority of the population is of Anglo descent; the minority, of Japanese descent.

3 Sydney Walker, "Designing Studio Instruction: Why Have Students Make Artworks?" *The Journal of Art Education*, September 1996, 11–17. More information on providing students choices for art-making.

4 Lori Groendyke, art teacher, Harrison Street Elementary School, Sunbury, Ohio. Sunbury is a rural, white, working-class community.

5 See note 4 above.

6 Personnel at the Getty Education Institute for the Arts, Los Angeles, California.

Chapter

5

General Recommendations for Interactive Group Critiques

This chapter offers suggestions for facilitating good interactive group discussions about students' artworks.

If this way of teaching is new to you, start from your strengths. If you haven't facilitated a critique but would like to try one, begin with your strongest class and their best art project. Don't set high expectations; if there are some good interactions, you will have a successful start. A short discussion is fine; you can lengthen discussions as you and your students become more comfortable with critiques. Teach your students to speak one at a time and to listen to one another. After posing good questions (which takes practice), resist answering them and give enough time for students to consider how to answer. Tell your students that you are trying something new; then be patient with them and yourself.

Concentrate on being a facilitator rather than a critic. To get students to be better critics, facilitate their critical thinking and expression rather than giving them your ideas about the work they are discussing. Student artists may want your informed opinions about their work and may ask for them during critiques. You could provide your viewpoint after the critique or reinforce what classmates have said. Deflecting authority from you to your students helps them become independent thinkers.

Sometimes allow students to choose what artworks to discuss. Although professional critics are sometimes given assignments by their editors, they often choose what they want to write about. They choose artists who interest them, exhibitions that they are enthused about reviewing, and artworks on which they want to concentrate. Try beginning some critiques by asking the students to choose the artworks they would like to discuss. By not imposing your choice, you have more assurance of their interest. If they ignore an artwork that you think they should

consider, introduce that work into the discussion at a later point.

Don't feel obliged to discuss the work of every student every time. Discussing every artwork responsibly during a critique is usually not feasible. Having to direct the discussion to include every work every time may lead to quick, shallow responses, rather than thoughtful discussions during which each student's comments build thoughtfully upon another's. If a good conversation develops about a particular work, the opportunity for learning might be greater if you stay with that work. Throughout the year, however, check that no student's work is being ignored.

Tell students beforehand that the discussion will not cover everyone's work, and try to leave some time at the end of a critique to ask for remarks or questions about works not mentioned. If someone's artwork has been ignored and the artist wants some feedback, encourage him or her to ask that the work be discussed.

Extend students' comments. When students say, "I agree" or "She said it already" or "That's just what I was going to say," ask them to reiterate the point in their own words ("Please say it in your own words" or "I'd like to hear it again from you"). Often when someone does reiterate, he or she presents a modification that might extend the original point and keep the discussion going.

Try to get everyone involved. Some students are slow to join a conversation. As long as they are attentive, let them move at their own pace. If they don't volunteer to speak over a long time, call on them by name, help them verbalize a response, and

then reinforce their participation. If some students are being non-responsive and disruptive, try to end the disruption but do not let them discourage you from continuing. Concentrate on the many who are involved. Eventually the reluctant ones will join in, especially if they see that others are having a good time thinking and talking.

See that no one dominates the discussion. When someone monopolizes a discussion, watch the group to see if most are interested and listening or if they have mentally wandered off. If they are disinterested, gently interrupt the speaker to keep the discussion moving and get back the group's attention. Before a discussion, remind students to give only one thought each time they speak so that the talk stays focused.

Pursue answers with follow-up questions. Ask for reasons to support statements. So that a student doesn't feel criticized by your asking more questions, say, "I think I agree with you, and I would like to hear more of what you are thinking," or "Yes, I think you have a good point. Tell us more." Conversely, say, "I'm not sure I agree with you. Can you show me evidence for your statement?"

Keep the artist's input to a minimum. To keep the artist's input to a minimum, call on the viewers to talk about the work. Students need practice to become good viewers and critics of artwork. Relying on the artist to explain what he or she has made does not reinforce good critical analysis.

Have the speakers comment to the class, not the artist. Direct speakers to talk to the class, not to the artist or you. Since a critique usually deals with the work of a student peer who is present, speakers tend

Try This

Ask some of these interpretive questions during a critique.

- Based on what you see, what attitude does the artwork communicate?

- What is the artwork for or against? What makes you think so? Does the artist approve or disapprove of what is shown? How do you know? What evidence is there in the artwork?

- Is this an optimistic or a pessimistic view of what is shown?

- What seems most important in this artwork? How do you know?

- Is there any indication in the artwork of the age of the artist? The artist's gender? Spiritual beliefs? Cultural background? Economic status? Where the artist lives?

- What does this artwork indicate about the time in which it was made? Could it have been made at any time and place, or only at a specific time and place? What evidence do you have for your answers?

- Might this artwork be offensive to someone? If so, why?

- If you were to hang these artworks in a gallery, what order would they be in? Why? Which ones seem to belong together? Are there some that do not belong?

to direct their comments to the student artist. A good critique is a whole-group discussion, not comments solely for or to the artist or the teacher.

Plan your critiques. Review the artworks to decide whether you or the students will select the works to talk about. Consider works that you want to focus on, and plan questions according to what you want to accomplish. Do you want to review what the students were to have learned? Will you use the critique as an assessment of their learning? Of your teaching? Do you want to teach something new during the critique? Once you have clarified your desired outcomes, phrase your questions and write them on paper. Write follow-up questions in case students are not forthcoming with answers to your original questions.

Decide whether you want the discussion to be descriptive, interpretive, or judgmental. As the teacher leading the critique, you can choose beforehand whether the session will be about improving the artworks or about accomplishing other goals, such as helping students become perceptive interpreters of art.

A critique can be primarily descriptive: students tell about their experience with an artwork; they can describe what they see when looking at a work. Critiques can be primarily interpretive: the focus is on two questions—What is this work about? How do you know? Critiques can be judgmental: students determine if a work is good, or how it is good.

Have students discuss the art as it is. Studio critiques in which participants are allowed to discuss how the work should be—rather than how it is—reinforces

mentally improving all art when viewing it, even that made by master artists. When discussing art, especially that by a mature artist, it is best to assume that the artist made sophisticated and carefully considered choices.

Try to be adaptable. Changing plans, thinking on your feet, and altering course if you are not getting the desired results are all part of being necessarily adaptable during a critique. Good critiques are ongoing, spontaneous discussions, even when they are preplanned.

Base judgmental critiques on criteria. A complete critical judgment consists of an appraisal based on reasons based in criteria. For example, William Wegman makes good photographs of dogs (appraisal). They are very funny and make insightful comments on being human (reasons). Art that entertains and informs is good art (criteria).

Many remarks that students make about art are judgmental decrees, asserted without reasons or criteria. But students can usually offer reasons when asked for further elaboration. An exchange like the following will help students make good judgments.

Student That's cool.

I like it too. But do you think it is a good work of art? Why?

Student It's cool.

How is it cool?

Student It makes me laugh, and I've never seen anything like this before.

So, art that is different and gets your attention through humor is good.

Student Yes.

That's a good answer. You gave reasons for your judgment.

Often, criteria are implicit. When students offer reasons in support of a judgment, articulate the implied criteria for the class, or ask questions so that students can decipher their own criteria.

You can pursue a discussion with further questions: Can you think of other artworks that have these two qualities? Are humor and being different sufficient qualities to make an artwork good, or should there be something else? Must all art be entertaining and different?

During interpretive discussions, seek the expressive qualities of the piece. The generic question "What has the artist shown us?" can be modified many ways and asked of all artworks. It directs viewers to be interpretive, and reminds them that art is always about something and always has a point of view. The question does not ask what the artist was thinking or what the artist was trying to do. We want to teach students not to be mind readers, but to be observant interpreters of art.

Listen carefully to the speaker; then formulate a response. Model good discussion techniques for the group by listening carefully. If you have to pause to formulate a new question, tell the group what you are doing. The students will take your question seriously because they will see that you are serious in posing it. You will also be modeling the advantages of listening before talking, and thinking before speaking.

 Try This

Let students know where you are going in a critique and what you want them to learn. Use statements like the following to remind students about the topic under discussion and to redirect their attention when it wavers.

- "I'm going to change the question now. We've been talking about which techniques work, but now I want you to think about how the technique affects the meaning of the piece."

- "When you say that you think the piece is good, you are judging it. For now, try to interpret what the picture is about, not whether it is good."

- "Yes, the colors are very saturated, but right now we're trying to figure out what the colors express. Do you have an idea about this?"

Be sure that everyone can see the work being discussed. If students cannot see what they are supposed to talk about, and what another is talking about, behavior problems will emerge. Plan the students' seating carefully.

Be sure the speaker is audible to everyone. Stand behind the listener who is furthest away from the speaker to motivate the speaker to speak more audibly. When students are speaking too softly, tell them: "You have to speak more slowly and loudly," or "I think you are saying good things and I want to hear them, and I want everyone in the class to be able to hear you." Tell the speakers to project their voices to those sitting furthest away.

Disallow side conversations. Side conversations are distracting and non-contributory to the whole group. If comments are made to another and not to the whole group, the group is disadvantaged by not hearing the comment. If you allow side conversations to go on, soon you will have a series of private conversations rather than a group discussion. If there is a need for small group discussion, then call for one. Break the large group into smaller units, let the students talk in small groups, and then ask them to report back to the reconvened whole group. Some students are shy and not willing to speak to the whole class, and allowing them time to talk in smaller groups may build their confidence in conversing about art.

Reflect. Consider how the discussion went. If it went well, think about why. If it did not go well, make necessary changes, and keep a record of the changes and the results you obtained. Videotape the critiques so that you can more accurately review what happened.

Keep yourself motivated by trying new things. Enjoy your teaching by keeping yourself intellectually and emotionally alive by trying different strategies during critiques that are exciting to you as a teacher.

Appendix

Worksheet 1
Interpreting Art

Answer these questions about the artwork you are viewing. If you are working with other students, choose one student to write down what the group decides. Then discuss the artwork as a group.

What do you see?

What does it mean?

How do you know?

Worksheet 2
Artist's Intent, Viewer's Interpretation

Artist: Write what you meant to express through your artwork.

Now fold back the paper so that what you have written cannot be seen.

Viewer: Without looking at what the artist wrote, write what you think the artwork is about and what it means to you.

Artist and Viewer: Based on what each of you wrote, have a conversation about the artwork. Then share your ideas with the rest of the class.

Worksheet 3
Artist's Intent, Viewer's Interpretation, Artist's Response

Artist: Write what you meant to express through your artwork.

Now fold back the paper so that what you have written cannot be seen.

Viewer: Without looking at what the artist wrote, write what you think this work is about and what it means to you.

Artist: Read the viewer's comments and think about them carefully. If you then would want to change your artwork to improve it and better communicate your intent, write notes about what you would do.

Index

A

aesthetics
 discussion of, 38-41, 48, 67-69,
 86-91
 media and, 67-69
 philosophical questions of, 30, 38
 photography and, 30, 69
 value, 71-72, 87-88
after-school art program, 38
age groups, mixing, 23-27,
 38-41, 45
analysis, discrepancy in, 4, 53,
 72-76
approval and advice, 2, 89-91
art
 criticism, 5, 12, 38-41, 47, 87-88
 expressionistic, 39-40
 handling of, 43
 history, 5, 63-66
 imagination and, 39-41
 making, xii, 91
 nature of, 67-69
 realistic, 28-30, 32-33, 39-40, 68,
 82-84
 value of, 86-88
 visual, 38
 writing about, 24, 42, 75
art critic, 5, 12, 20-21, 23, 33, 44, 80
artistic
 influences, 63-67
 process, 17
 reason, 86-88
artist's
 background, 64-67
 intent, 48-50, 53-55, 56, 74, 76
 involvement, 50-55, 88-89
artwork
 deciphering, 43-44, 53-55
 discussed, v, 23-24, 56
 questioning of, 8, 30, 48
assessment
 basis for, 88-89
 critique to, 17-19, 45
 information, 11
 learning, iv, 17-19
 teaching, 17-19, 25
attention, redirecting, 10, 12, 28,
 76, 97

B

Barthes, Roland, 69
batik, 17-19, *18*
Bauhaus, 69
Butterfield, Deborah, 80-82, *82*

C

camera, 67-68
ceramic objects, critiques of, 41-45,
 70-77
chalk, 20
circles, use of, 15
collaboration, v, 16
collage, 68-69, 85-86
color
 natural and transformed, 67-68
 patterns, 38
 use of, 85-88
comparative thought, 25, 80
compare and contrast, 29-30, 81
competition, 3
construction paper collage, *84*
craftsmanship, 85, 89
creativity, discussed, 71, 87
criteria, 4, 96
critic, art, *see* art critic
critical discussions, xii, 7-8
criticism, *see* art criticism
critique(s)
 approval and advice, 2, 89-91
 criteria for, 12, 96-98
 criticism and, 5
 descriptive, 96
 experiences, 2-4
 goals of, 41, 91, 97
 group, 89-91, 94-98
 influences and, 63-67
 interpretive, 32, 41-44, 77,
 80-82, 96
 interpretive questions, 95
 judgment and, 4, 80-89, 96
 kinds of, 90
 media, 56-58

negative and positive, 32-34
planning, 96
research, 25-27
student's involvement, 94-98
studio, xii, 2-5
teacher's role, 4-5
themes in, 28-31,
uses of, 5, 45
viewer's role, 4-5
Cubism, 13-17
cultural influences, 38, 63-67
curator, questions for, 66
curriculum planning, iv, 13

D

Dali, Salvador, 63
David (Michelangelo), 65
descriptive depth, comments, 12,
 20-22, 34-37
descriptive evidence, 4-5, 12, 48
design, 29, 70-71
detail, attention to, 37
dialogue, facilitating, v
disciplines, integrating, 30-31
discussion
 disagreement and, 34
 evaluative, xiii, 80, 84
 interpretive, xiii, 44, 64-67,
 70-74, 96, 97
 peer, v, 44-45
 techniques, 97
draftsmanship, 40
drawing(s)
 inferring meaning, 34-37
 mixed-media, 20-22
 photography and, 67-69
 self-portraits, 32-34
dye, using, 18, 19

E

emotion, artworks and, 10, 13-17,
 40
evaluative questions, 48-49, 80
exercises, Try This
 artistic intent, 48, 49, 56, 64
 assess understanding, 17, 88
 audience appeal, 24

Afterword

This book is a collection of diverse voices, students' and teachers', all interpreting and valuing art, all working together, listening to each other, and enriching their lives in a climate that respects art and people interested in art.

Conducting the research for this book provided me with learning opportunities as a teacher of students and a teacher of teachers. I learned from both young and older students and from their classroom teachers and art specialists. I saw some very good art, and participated in engaging, stimulating conversations with a diversity of students in various situations.

As teachers, we can make changes in the most effective place—classrooms across the country. The experiences related in this book have given me new hope for art education because I have seen what good art young people can create, and have experienced with students and teachers the excitement that can come with thinking and talking about student art.

About the Author

Before becoming a professor, Terry Barrett taught art to inner-city high school students and to young children in after-school programs. For the past twelve years, he has worked with students of all ages in schools and museums as an Art Critic-in-Education for the Ohio Arts Council. As a Professor of Art Education at Ohio State University, Barrett teaches courses in criticism for which he has received a distinguished teaching award. He is the author of *Criticizing Art: Understanding the Contemporary*, and *Criticizing Photographs: An Introduction to Understanding Images*, the editor of the anthology *Lessons for Teaching Art Criticism*, and past editor of the research journal *Studies in Art Education*.